The Artist's Painting Library

ACRYLIC PAINTING

BY WENDON BLAKE / PAINTINGS BY RUDY DE REYNA

WATSON-GUPTILL PUBLICATIONS/NEW YORK

P9-DIY-084

Copyright © 1979 by Billboard Ltd.

First published 1979 in the United States and Canada by Watson-Guptill Publications,
a division of Billboard Publications, Inc.,
1515 Broadway, New York, N.Y. 10036

Library of Congress Cataloging in Publication Data
Blake, Wendon.
 Acrylic painting.
 (His The artist's painting library)
 Originally published as pt. 1 of the author's The
acrylic painting book.
 1. Polymer painting—Technique. I. De Reyna,
Rudy, 1914- II. Title. III. Series.
ND1505.B552 1979 751.4'26 79-11815
ISBN 0-8230-0068-0

All rights reserved. No part of this publication may be
reproduced or used in any form or by any means—graphic,
electronic, or mechanical, including photocopying, recording,
taping, or information storage and retrieval systems—
without written permission of the publishers.

Manufactured in Hong Kong

First Printing, 1979
6 7 8 9/86

CONTENTS

Painting in Acrylic. For as long as human beings have painted pictures, artists have searched for the ideal painting vehicle. In the manufacture of paint, the vehicle is the liquid glue that's blended with powdered color to produce the colored paste you squeeze out of the tube. The brilliance, durability, and handling qualities of paint depend, above all, on the character of the vehicle. And for many artists, the acrylic vehicle comes close to being the ideal. The acrylic vehicle is a cloudy liquid with a consistency somewhat like cream. When wet, you can dilute it with water. When dry, it's no longer soluble in water, forms a leathery coating, and turns as clear as glass. Thus, each granule of colored pigment is encased forever in a tough, waterproof coat of invisible plastic.

Ways of Painting. There are so many ways of painting with acrylic that no book can possibly do justice to them all. However, there are certain basic techniques that every acrylic painter should master, so we'll begin with these. Then you'll see Rudy de Reyna—a noted contemporary artist who works in a variety of acrylic techniques—paint thirteen demonstration pictures that show you how to put these basic techniques into practice. Finally, you'll learn a variety of special techniques—which artists like to call "technical tricks"—and several methods of correcting acrylic paintings when things go wrong.

Opaque Technique. The simplest way to work with acrylic is to squeeze color directly from the tube onto the palette, brush in just enough water to produce a creamy consistency, and then apply masses of solid color to the painting surface. The creamy color immediately covers the canvas, paper, or board underneath. And the second layer of color will hide the first. For obvious reasons, this is called the opaque technique. It's a rapid, direct way to paint. You'll see how it's done.

Transparent Technique. If you add much more water to the tube color, you'll produce a pool of tinted water called a wash. You can see right through it to the surface of your palette, and you'll also see through the transparent color when you brush it onto the painting surface. The dried paint is like a sheet of colored glass. A second coat will modify the first—the two coats will mix in the viewer's eye—but one coat won't conceal another. That's why this is called the transparent technique.

Scumbling and Drybrush. To create tonal gradations from dark to light, or to shade one color into another, it's important to learn two ways of handling the brush. Scumbling is a kind of scrubbing motion that spreads a veil of color across the surface. Drybrush is a method of skimming the brush across the painting surface so that the paint hits only the high points of the textured canvas or paper, leaving behind flecks of color wherever the brush touches the ridges.

Combining Techniques. Naturally, there are many ways of combining these techniques. In painting a portrait head, it's common to paint the lighted areas opaquely and then paint the shadows in transparent color. The soft transitions from light to shadow, at places such as the cheek or the brow, might be produced by scumbling. Then details like the bony structure of the nose and the eye sockets might be rendered in drybrush. As you spend more time working with acrylics, you'll find your own combinations.

Painting Demonstrations. De Reyna begins his painting demonstrations with simple objects such as fruit, flowers, and kitchenware. These are the best subjects to start with when you're learning how to handle brushes and color. Then he moves on to four outdoor subjects: summer, autumn, winter, and coastal landscapes. You'll find that these landscapes incorporate various techniques. Some are painted broadly and others are done with more precise brushwork. You'll see examples of opaque painting, transparent painting, and combinations of both. Last, de Reyna demonstrates the hardest subjects of all: a male and a female portrait head. Thus, the painting demonstrations progress from the simplest subjects to the most demanding.

Special Techniques. Following the demonstrations, you'll learn some unlikely techniques such as scratching, painting with a scrap of cloth folded into a dabber, painting with a wad of crumpled paper, spattering, painting with a sponge, and the impasto method—which means working with thickly textured paint. Of course, no painting is ever perfect and you'll certainly want to know how to amend something that's gone wrong—so you'll learn three methods of correcting an acrylic painting. Fittingly enough, the last thing you'll learn will be how to preserve your acrylic paintings for years of pleasure.

Color Selection. The paintings in this book were all done with a dozen basic colors,—colors you'd normally keep on the palette—plus a couple of others kept on hand for special purposes. Although the leading manufacturers of acrylic colors will offer you as many as thirty inviting hues, few professionals use more than a dozen, and many artists get by with fewer. The colors listed below are really enough for a lifetime of painting. You'll notice that most colors are in pairs: two blues, two reds, two yellows, two browns, two greens. One member of each pair is bright, the other subdued, giving you the greatest possible range of color mixtures.

Blues. Ultramarine blue is a dark, subdued hue with a hint of violet. Phthalocyanine blue is far more brilliant and has tremendous tinting strength—which means that a little goes a long way when you mix it with another color. So add it very gradually.

Reds. Cadmium red light is a fiery red with a hint of orange. All cadmium colors have tremendous tinting strength; add them to mixtures just a bit at a time. Naphthol crimson is a darker red and has a slightly violet cast.

Yellows. Cadmium yellow light is a dazzling, sunny yellow with tremendous tinting strength, like all the cadmiums. Yellow ochre (or yellow oxide) is a soft, tannish tone.

Greens. Phthalocyanine green is a brilliant hue with great tinting strength, like the blue in the same family. Chromium oxide green is more muted.

Browns. Burnt umber is a dark, somber brown. Burnt sienna is a coppery brown with a suggestion of orange.

Black and White. Some manufacturers offer ivory black and others make mars black. The paintings in this book are done with mars black, which has slightly more tinting strength. But that's the only significant difference between the two blacks. Buy whichever one is available in your local art supply store. Titanium white is the standard white that every manufacturer makes.

Optional Colors. One other brown, popular among portrait painters, is the soft, yellowish raw umber, which you can add to your palette when you need it. Hooker's green—brighter than chromium oxide green, but not as brilliant as phthalocyanine—may be a useful addition to your palette for painting landscapes full of trees and growing things. If you feel the need for a bright orange on your palette, make it cadmium orange—although you can just as easily create this hue by mixing cadmium red and cadmium yellow.

Gloss and Matte Mediums. Although you can simply thin acrylic tube color with water, most manufacturers produce liquid painting mediums for this purpose. Gloss medium will thin your paint to a delightful creamy consistency; if you add enough medium, the paint turns transparent and allows the underlying colors to shine through. As its name suggests, gloss medium dries to a shiny finish like an oil painting. Matte medium has exactly the same consistency, will also turn your color transparent if you add enough medium, but dries to a satin finish with no shine. It's a matter of taste. Try both and see which finish you prefer.

Gel Medium. Still another medium comes in a tube and is called gel because it has a consistency like very thick, homemade mayonnaise. The gel looks cloudy as it comes from the tube, but dries clear. Blended with tube color, gel produces a thick, juicy consistency that's lovely for heavily textured brush and knife painting.

Modeling Paste. Even thicker than gel is modeling paste, which comes in a can or jar, and has a consistency more like clay because it contains marble dust. You can literally build a painting 1/4″ to 1/2″ (6 mm to 12 mm) thick if you blend your tube colors with modeling paste. But build gradually in several thin layers, allowing each one to dry before you apply the next, or the paste will crack.

Retarder. One of the advantages of acrylic is its rapid drying time, since it dries to the touch as soon as the water evaporates. If you find that it dries *too* fast, you can extend the drying time by blending retarder with your tube color.

Combining Mediums. You can also mix your tube colors with various combinations of these mediums to arrive at precisely the consistency you prefer. For example, a 50-50 blend of gloss and matte mediums will give you a semi-gloss surface. A combination of gel with one of the liquid mediums will give you a juicy, semi-liquid consistency. A simple mixture of tube color and modeling paste can sometimes be a bit gritty; this very thick paint will flow more smoothly if you add some liquid medium or gel.

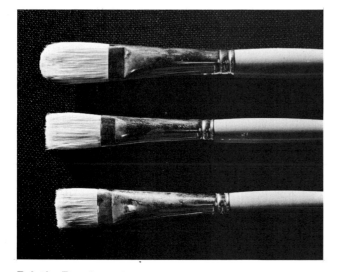

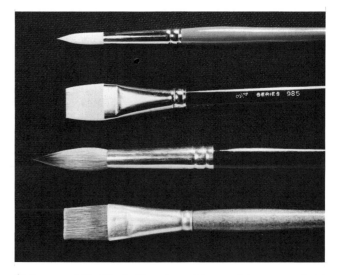

Bristle Brushes. For acrylic painting, you can use the same bristle brushes normally used in oil painting. The top brush is called a *filbert*; its long body of bristles, coming to a rounded tip, will make a soft, fluid stroke. The center brush is called a *flat*; its square body of bristles will make a squarish stroke. The bottom brush is called a *bright*; its short, stiff bristles can carry lots of thick paint and will make a stroke with a distinct texture. Bristle brushes are particularly good for applying thick color.

Nylon and Softhair Brushes. For applying more fluid color, many painters prefer softhair brushes. The top two are soft, white nylon; the round, pointed brush is good for lines and details, while the flat one will cover broad areas. The third brush from the top is a sable watercolor brush, useful for applying very fluid color. (You can also buy a big, round brush like this one in white nylon, which will take more punishment than the delicate sable.) The bottom brush is a stiffer, golden brown nylon, equally useful for applying thick or thin color.

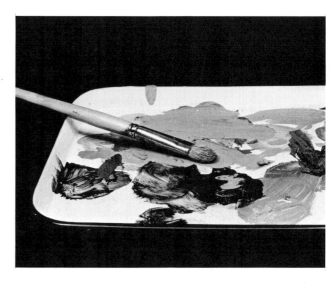

Watercolor Palette. This white plastic palette was originally designed for watercolor painting, but it works just as well for acrylic painting. You squeeze your tube color into the circular "wells" and then do your mixing in the rectangular compartments. These compartments slant down at one end; thus the color will run down and form pools if you add enough water.

Enamel Tray. For mixing large quantities of color, the most convenient palette is a white enamel tray—which you can buy wherever kitchen supplies are sold. You can use this tray by itself or in combination with one or two smaller plastic palettes like those used for watercolor.

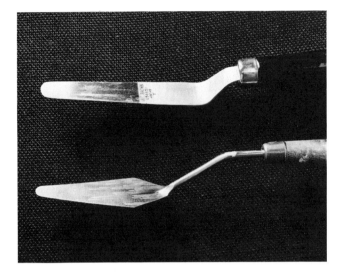

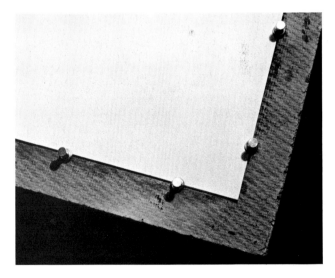

Knives. A palette knife (top) is useful for mixing thick color on your palette—before you add a lot of water—and for scraping wet color off the painting surface if you're dissatisfied with some part of the painting. A painting knife (bottom) has a thin, flexible blade which is designed to pick up thick color from the mixing surface and spread it on the painting surface. The side of the blade will make broad strokes, while the tip can add small touches of color.

Easel. For painting on canvas boards, canvas, or panels made of hardboard, most artists like to work on a vertical surface. A traditional wooden easel will hold the painting upright. An easel is essentially a wooden framework with two grippers that hold the painting firmly at top and bottom. Be sure to buy an easel that's solid and stable; don't get a flimsy easel that will tip over when you get carried away with vigorous brushwork.

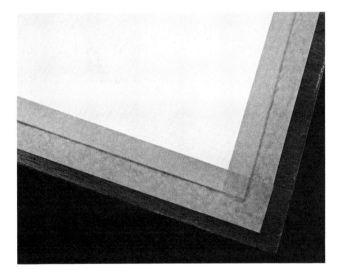

Wooden Drawing Board. When you paint on watercolor paper—or any sturdy paper—it's best to tape the paper to a sheet of plywood or a sheet of hardboard cut slightly bigger than the painting. If you can, buy plywood or hardboard that's made for outdoor construction work; it's more resistant to moisture. Hold down the edges of the painting with masking tape that is at least 1″ (25 mm) wide or even wider.

Fiberboard. Illustration board is too thick to tape down, so use thumbtacks (drawing pins) or pushpins to secure the painting to a thick sheet of fiberboard. This board is 3/4″ (about 18 mm) thick and soft enough for the pins to penetrate. Note that the pins don't go *through* the painting, but simply overlap the edges.

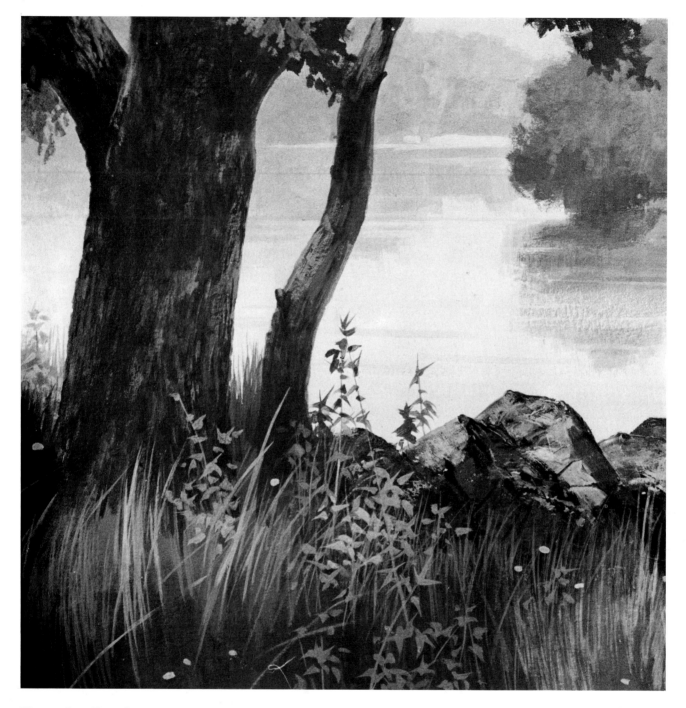

Illustration Board. The most widely used surface for acrylic painting is illustration board, which is sturdy, white drawing paper mounted on stiff cardboard. The most popular, all-purpose illustration board comes in a so-called kid finish, which has just enough texture to accentuate the rough brushwork on the treetrunk. But it's also smooth enough for the precise, linear brushwork of the weeds and grasses in the foreground. Manufacturers of acrylic paints usually make a thick, white paste called acrylic gesso, which you can brush onto illustration board to make a particularly receptive painting surface. The gesso comes in cans or jars. If you like a smooth painting surface, dilute the gesso with water to a milky consistency and apply several coats. If you like a rougher painting surface, use the gesso straight from the jar (or with just a little water) and apply it with rough brushstrokes. Paint both sides of the board so that it won't warp.

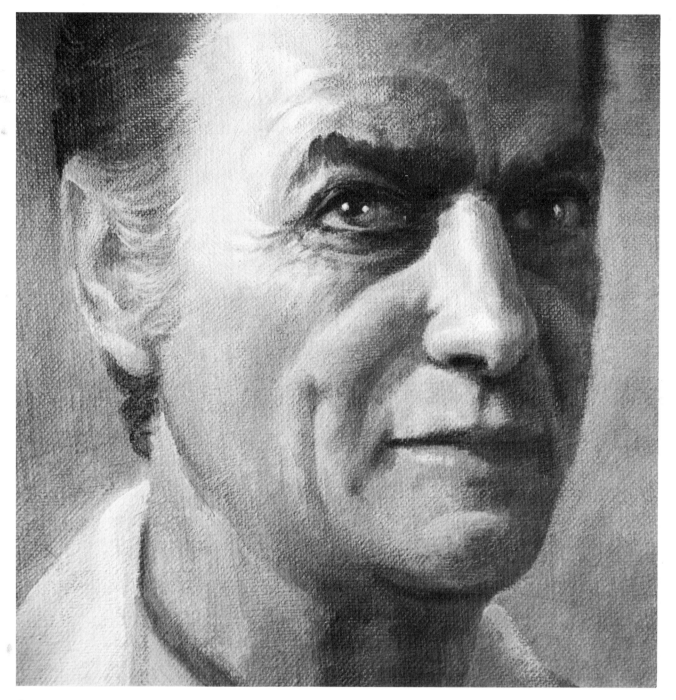

Canvas. The woven texture of canvas has a lovely way of softening the brushstroke. That's why canvas is particularly good for painting portraits and figures, with their delicate transitions from light to shadow, as you see on the forehead, cheeks, nose, chin, and neck of this portrait head. Canvas boards, available in every art supply store, are inexpensive canvas glued to sturdy cardboard. If you buy canvas in rolls or mounted on wooden stretcher bars, the fabric is usually precoated with white paint; make sure it's white acrylic, not white oil paint. You can also buy uncoated linen or cotton canvas, then brush on several coats of acrylic gesso. And you can make an excellent painting surface by buying sheets of hardboard and coating these with acrylic gesso.

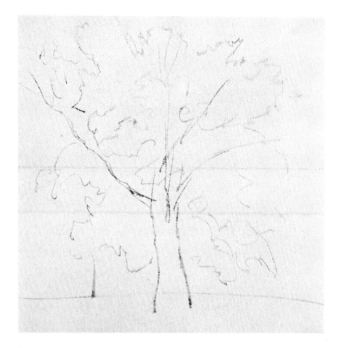

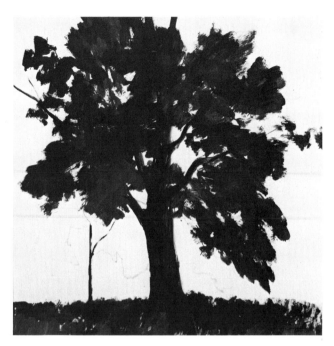

Step 1. For your first taste of acrylic painting, choose a simple subject like a tree. On a white sheet of illustration board or a thick, sturdy sheet of white drawing paper, make a free pencil drawing, indicating the main shapes of the tree.

Step 2. You're going to work from dark to light, so brush in the overall shape of the tree and the ground with mixtures that are actually the darkest colors in your picture. Don't thin your tube color too much—just a few drops of water or medium will do, keeping it a rich, creamy consistency so that the paint really covers the paper. Allow this first layer to dry.

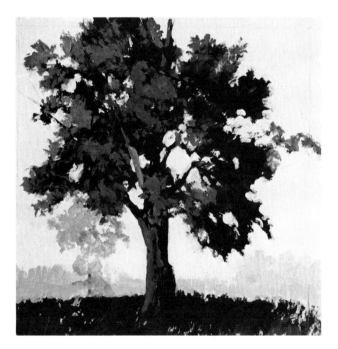

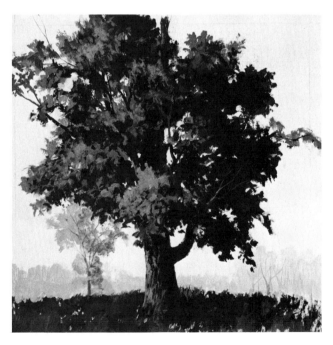

Step 3. Mix some paler tones for the sunlit parts of the tree and brush them over the darks, which now really look like shadows. Then mix even paler tones for the sky, brushing them around the leafy mass and punching some holes into the tree where the sky shows through. These lighter tones should be thick and creamy so that they really cover the darks underneath.

Step 4. Always save your small details for the very end. Now you can use opaque light and dark strokes to pick out individual branches, to suggest the texture of the bark, and to indicate a few leaves. The secret of the opaque technique is that each stroke is thick and solid enough to cover what's underneath.

Step 1. Now try the transparent technique by painting another tree with very fluid color that's diluted with a lot of water. On a white sheet of watercolor paper—or another piece of illustration board, if you prefer—start with a free pencil drawing that outlines the lusters of leaves, the trunk, and the landscape background.

Step 2. Mix some pale *washes*, as they're called, thinning your tube color with lots of water. With a round, softhair brush, block in the palest tones of the picture with free, relaxed strokes: the general shapes of the leafy masses, the trees along the horizon, and the shadows in the foreground. Don't be too precise and don't think about details just yet.

Step 3. Next, mix some darker tones on your palette. You're still using plenty of water, but not quite so much as you used in Step 2. Work with big, free strokes, darkening some parts of the tree and some areas of the trees in the background. Let the wet strokes overlap so that they blur together.

Step 4. When the previous step is dry, mix some even darker washes—less water, though still fluid—and darken the shadowy areas of the leafy masses. Paint the trunk and branches with the tip of the brush. The tip is also used to add some trunks to the distant trees and to darken the shadows in the foreground, suggesting some blades of grass.

Step 1. Drybrush is a method of producing subtle dark-to-light gradations by skimming the brush lightly over the surface of the paper. The brush is damp, never sopping wet, because the color doesn't contain too much water. It's important to work on a surface that has a distinct texture. This demonstration is painted on rough illustration board, but you can also use watercolor paper. To learn how to handle drybrush, pick some simple, natural form like this onion. Begin with a careful pencil drawing that defines the outer edge of the form.

Step 2. Cover each major color area with a thin layer of fluid color. Dilute the color with enough water to produce a milky consistency—not thick enough to obliterate the texture of the painting surface. Let each area dry before you paint the next.

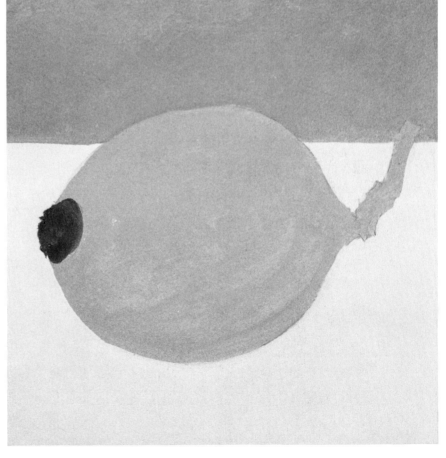

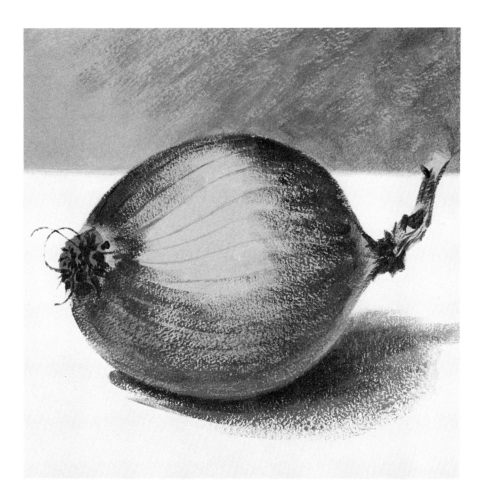

Step 3. Start by mixing the shadow tones, adding just enough water to make the paint brush easily. Move the brush lightly over the textured painting surface, hitting the peaks and skipping over the valleys so that color is deposited on the high points, while the low points shine through as lighter flecks. Move the brush back and forth over certain areas and press a bit harder to deposit more paint and make those areas darker. You can see these darks at the top of the onion, to the extreme right, and in the shadow beneath. The background is also darkened with drybrush strokes.

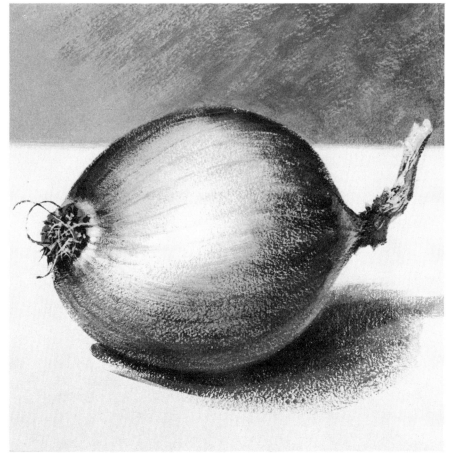

Step 4. Now wash out the brush, draw it across a paper towel to get rid of most of the water, and pick up lighter tones for the center of the form. Once again, skim the brush over the rounded form, curving the strokes to follow the shape of the onion, moving back and forth and pressing harder to deposit more color. Where the light strokes intersect with the darker strokes applied in Step 3, you get a soft gradation from light to dark. With the tip of a round, softhair brush and more fluid color, you can add lines and details.

Step 1. To learn the technique called scumbling, begin with some simple form like this pear. Work on a piece of illustration board or on a piece of sturdy, thick drawing paper that has a slight texture. Begin with a simple pencil drawing that outlines the form.

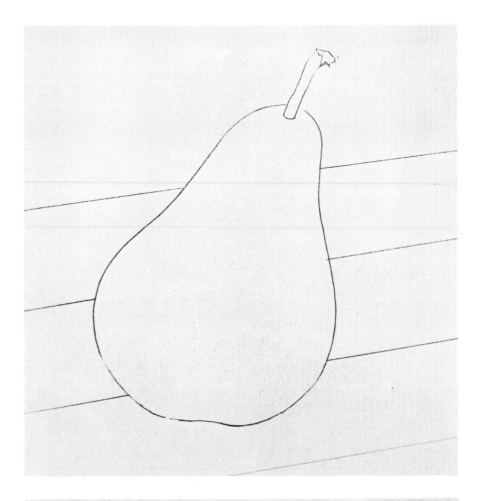

Step 2. On your palette, mix a tone for each of the main color areas. Add enough water to make the paint fairly fluid, like cream or milk. Cover each area with a flat tone. Allow each area to dry before you paint the next.

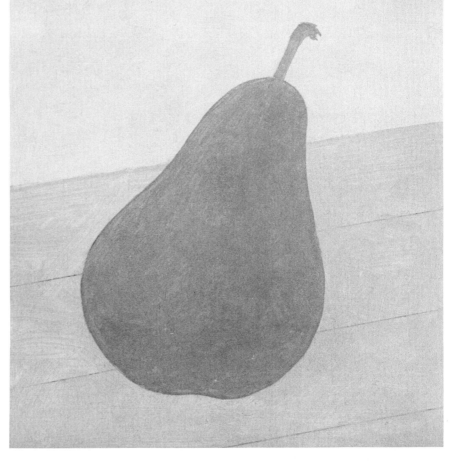

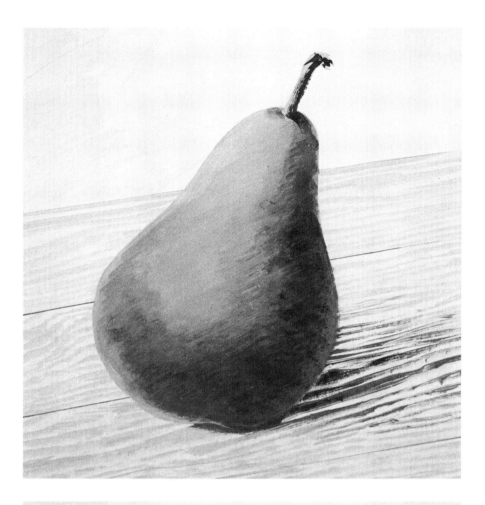

Step 3. Now mix a dark tone for the shadow side of the pear, pick up a bit of paint on the tip of a bristle or nylon brush, and apply the color in a series of strokes, moving the brush back and forth with a scrubbing motion that softens and blurs the stroke. Place some lighter strokes alongside the darker strokes so that you get the feeling of dark blending into middletone. You can also paint the grain of the tabletop with a pointed, softhair brush and more fluid color, placing darker strokes in the shadow area.

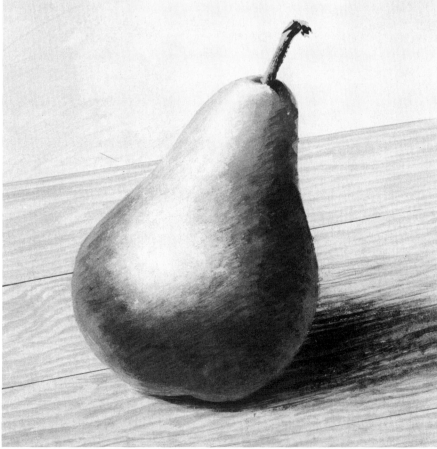

Step 4. Now mix a much lighter tone for the center of the pear. Again using a resilient brush, such as bristle or nylon, scrub on the color with a back-and-forth motion, blurring the light strokes as you approach the darker area of the pear. Placed side-by-side, the dark and light scumbled strokes will seem to blend into one another. You can also darken the shadow with more scumbling strokes.

Brushes. Because you can wash out a brush quickly when you switch from one color to another, you need very few brushes for acrylic painting. Two large flat brushes will do for covering big areas: a 1″ (25 mm) bristle brush, the kind you use for oil painting; and a softhair brush the same size, whether oxhair, squirrel hair, or soft white nylon. Then you'll need another bristle brush and another softhair brush, each half that size. For more detailed work, add a couple of round softhair brushes—let's say a number 10, which is about 1/4″ (6 mm) in diameter, and a number 6, which is about half as wide. If you find that you like working in the transparent technique, which means thinning acrylic paint to the consistency of watercolor, it might be helpful to add a big number 12 round softhair brush, whether oxhair or soft white nylon. Since acrylic painting will subject brushes to a lot of wear and tear, few artists use their expensive sables.

Painting Surfaces. If you like to work on a smooth surface, use illustration board, which is white drawing paper with a stiff cardboard backing. For the transparent technique, the best surface is watercolor paper—and the most versatile watercolor paper is mouldmade 140 pound stock in the cold pressed surface (called a "not" surface in Britain). Acrylic handles beautifully on canvas, but make sure that the canvas is coated with white acrylic paint, not white oil paint. Your art supply store will also sell inexpensive canvas boards—thin canvas glued to cardboard—that are usually coated with white acrylic, which is excellent for acrylic painting. You can create your own painting surface by coating hardboard with acrylic gesso, a thick, white acrylic paint which comes in cans or jars. For a smooth surface, brush on several thin coats of acrylic gesso diluted with water to the consistency of milk. For a rougher surface, brush on the gesso straight from the can so that the white coating retains the marks of the brush. Use a big nylon housepainter's brush.

Drawing Board. To support your illustration board or watercolor paper while you work, the simplest solution is a piece of hardboard. Just tack or tape your painting surface to the hardboard and rest it on a tabletop—with a book under the back edge of your board so it slants toward you. You can tack down a canvas board in the same way. If you like to work on a vertical surface—which many artists prefer when they're painting on canvas, canvas board, or hardboard coated with gesso—a wooden easel is the solution. If your budget permits, you may like a wooden drawing table that you can tilt to a horizontal, diagonal, or vertical, just by turning a knob.

Palette. One of the most popular palettes is the least expensive—just squeeze out and mix your colors on a white enamel tray, which you can probably find in a shop that sells kitchen supplies. Another good choice is a white metal or plastic palette (the kind used for watercolor) with compartments into which you squeeze your tube colors. Some acrylic painters like the paper palettes used by oil painters: a pad of waterproof pages that you tear off and discard after use.

Odds and Ends. For working outdoors, it's helpful to have a wood or metal paintbox with compartments for tubes, brushes, bottles of medium, knives, and other accessories. You can buy a tear-off paper palette and canvas boards that fit neatly into the box. Many acrylic painters carry their gear in a toolbox or a fishing tackle box, both of which also have lots of compartments. Two types of knives are helpful: a palette knife for mixing color; and a sharp one with a retractable blade (or some single edge razor blades) to cut paper, illustration board, or tape. Paper towels and a sponge are useful for cleaning up—and they can also be used for painting, as you'll see later. You'll need an HB drawing pencil or just an ordinary office pencil for sketching in your composition before you start to paint. To erase pencil lines, get a kneaded rubber (or "putty rubber") eraser, which is so soft that you can shape it like clay and erase a pencil line without abrading the surface. To hold down that paper or board, get a roll of 1″ (25 mm) masking tape and a handful of thumbtacks (drawing pins) or pushpins. To carry water when you work outdoors, you can take a discarded plastic detergent bottle (if it's big enough to hold a couple of quarts or liters) or buy a water bottle or canteen in a store that sells camping supplies. For the studio, find three wide-mouthed glass jars, each big enough to hold a quart or a liter.

Work Layout. Before you start to paint, lay out your supplies and equipment in a consistent way, so everything is always in its place when you reach for it. Obviously, your drawing board or easel is directly in front of you. If you're right-handed, place your palette, those three jars, and a cup of medium to the right. In one jar, store your brushes, hair end up. Fill the other two jars with clear water: one is for washing your brushes; the other provides water for diluting your colors. Establish a fixed location for each color on your palette. One good way is to place your *cool* colors (black, blue, green) at one end and the *warm* colors (yellow, orange, red, brown) at the other. Put a big dab of white in a distant corner, where it won't be fouled by the other colors.

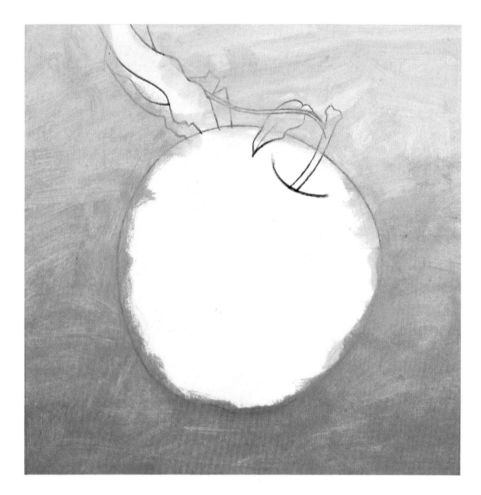

Step 1. To learn how to model form in acrylic—that is, how to paint something so it looks three-dimensional—start with some simple, familiar shape like an apple. It's important to begin with a careful pencil drawing of the form. This study of an apple begins with a line drawing that defines the round shape of the apple, its stem, and a couple of leaves. Then a bristle brush scrubs in the background tone, which is a mixture of ultramarine blue, burnt sienna, yellow ochre, and white. Notice that the tone is darker in the foreground, where it contains a bit more ultramarine blue and burnt sienna. It doesn't matter if these casual strokes overlap the edges of the apple.

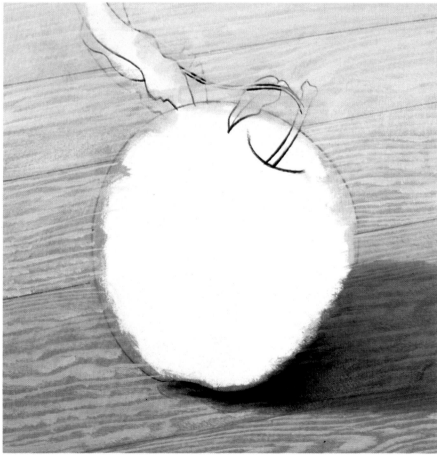

Step 2. The lines between the boards of the tabletop are drawn with a sharp pencil and a ruler. Then the tip of a round sable draws the grain of the tabletop with a paler version of the same mixture used to paint the background in Step 1. This mixture simply contains more white. A darker version of the same mixture—less white, more ultramarine and burnt sienna—becomes the shadow cast by the apple. The shadow tone is first painted with a bristle brush. Then the lines of the wood grain within the shadow are added with the tip of the round sable.

Step 3. Now the entire shape of the apple is covered with a flat tone. This is a blend of cadmium red, naphthol crimson, yellow ochre, and white, applied with a flat bristle brush. A very thin wash of yellow ochre, ultramarine blue, and burnt sienna—containing lots of water, but no white—is brushed over the leaves. A darker version of this same mixture, with less water, is used for the shadow areas on the leaves. The intricate forms of the leaves are painted with a round sable.

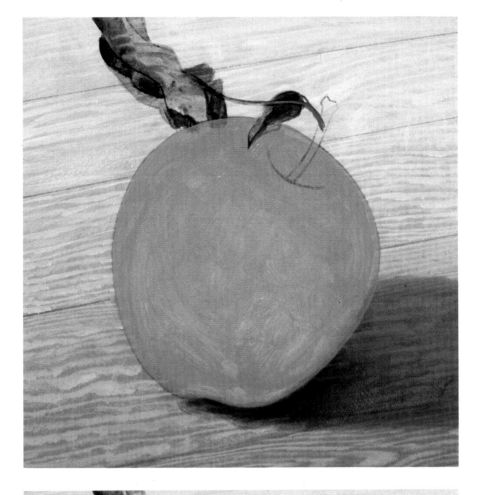

Step 4. Now it's time to start modeling the apple—which means adding darks and lights on top of the flat tone painted in Step 3. A round, softhair brush paints the dark red at the top of the apple in short, slender strokes that curve to follow the round shape. These strokes are a mixture of naphthol crimson, cadmium red, yellow ochre, and white. More white is added to these strokes as they move downward from the midpoint of the apple to the bottom. The highlights on the apple are mainly yellow ochre and white, with just a hint of the reddish mixture that's used to paint the rest of the apple. These lights are painted with scumbling strokes, so they seem to blend into the red.

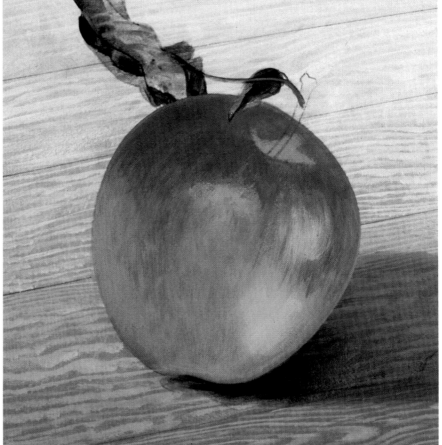

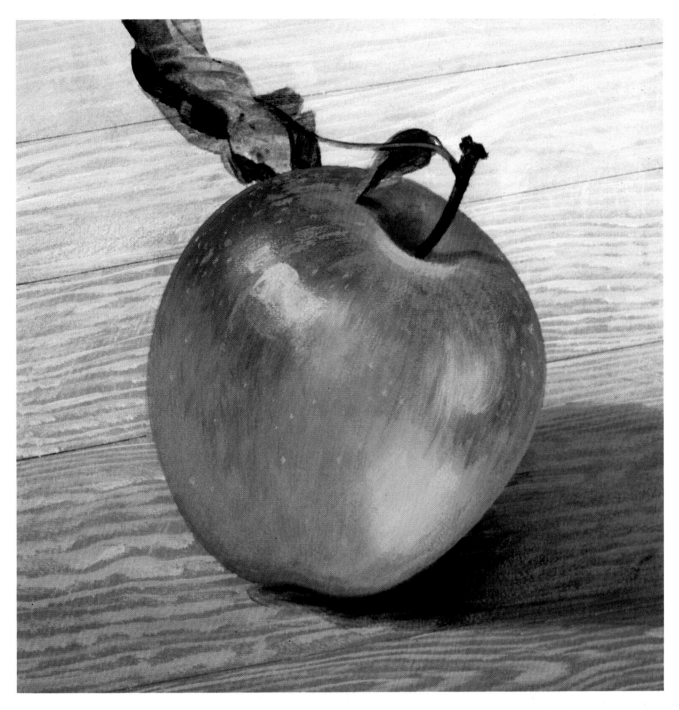

Step 5. Here's an enlarged close-up of the apple, so you can really see the brushwork. The precise details of the apple are saved for the final stage. The subtle tone around the stem is painted with the tip of a round, softhair brush carrying a mixture of ultramarine blue, yellow ochre, and burnt umber. Tiny spots of this mixture are added to the sides of the apple with the point of the brush. The stem is a dark mixture of burnt sienna and ultramarine blue. Now review the basic modeling procedure. You begin by painting the flat, overall tone of the subject. Then you block in the lights and darks. Next come the highlights. You finish with the details. And you'll enhance the three-dimensional feeling if your brushstrokes follow the form, just as the strokes curve around the apple here.

Step 1. Painting a slightly more complicated natural form such as this green pepper will give you an opportunity to develop your skill with drybrush. Once again, start with a simple pencil drawing and then brush in the background with free strokes. This demonstration is painted on watercolor paper whose slightly rough texture is especially good for drybrush. The tones of the wooden tabletop are drybrush strokes made by the edge of a bristle brush dampened with a mixture of ultramarine blue, burnt sienna, and white. The lighter strokes obviously contain more white. For the shadowy wall at the top of the picture, the same brush carries the same mixture.

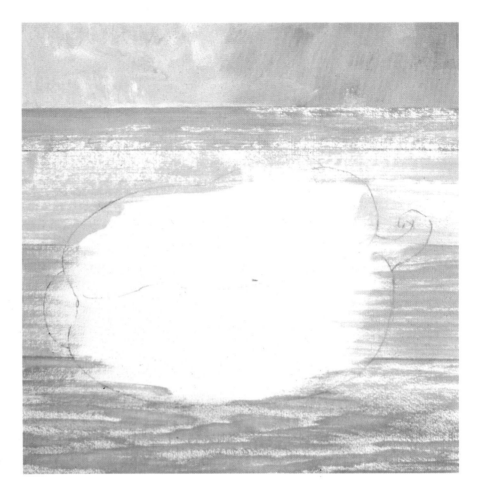

Step 2. To unify the strokes of the tabletop, the bristle brush coats the entire area with a transparent wash of burnt sienna and ultramarine blue—and lots of water. When this is dry, the entire shape of the pepper is covered with a mixture of phthalocyanine green, yellow ochre, a little burnt umber, and white. The lines in the center of the pepper are reinforced with the pencil, since they'll be helpful in guiding the modeling in Step 3.

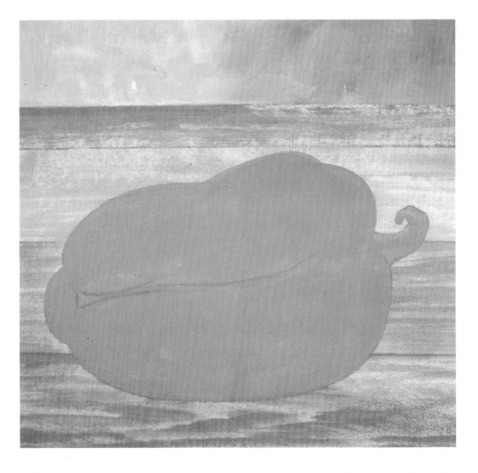

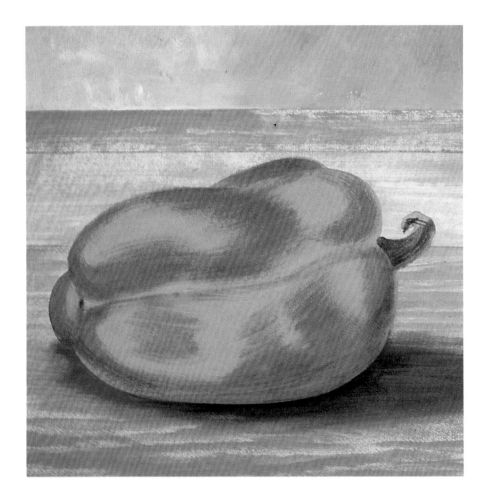

Step 3. Now the darks are added with a mixture of phthalocyanine green, burnt umber, and yellow ochre. There's just a bit of color on the brush so that the bristles are damp, not wet. And the brush skims quickly over the surface of the paper, depositing ragged, broken strokes rather than solid color. The darks are built up gradually, one stroke over another. The same method is used to paint the shadow cast by the pepper and to darken the grain of the tabletop in front of the pepper—mixtures of ultramarine blue, burnt umber, yellow ochre, and white. These soft drybrush strokes are executed with a round, softhair brush.

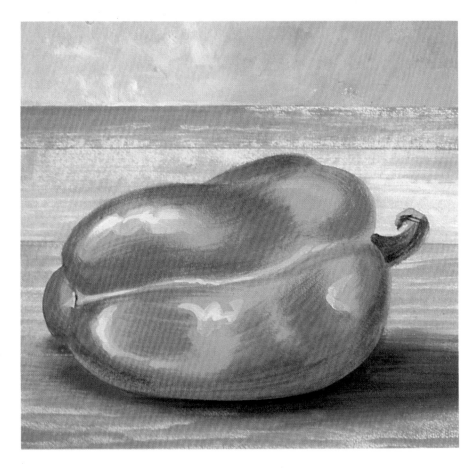

Step 4. Now the light areas between these shadowy strokes are strengthened with the same green mixture used in Step 2, but with a bit more white added. Finally, the highlights are added with the tip of a round, softhair brush. These are mainly white, with just a bit of the green mixture, plus lots of water. As you can see, drybrush is used mainly for modeling, while more fluid color is used for the precise, final touches.

Step 1. Painting the fuzzy surface of a peach is particularly good practice in the technique called scumbling. To make the job a bit easier, you might like to select a sheet of textured watercolor paper that will accentuate the scrubby character of the back-and-forth scumbling strokes. This demonstration begins with a pencil drawing that carefully defines the contours of the peaches, the dish, and the line of the tabletop. A flat, softhair brush covers the background with a fluid tone of black, yellow ochre, and a touch of white. The same brush covers the tabletop with this mixture, plus phthalocyanine blue and a lot more white.

Step 2. Ultramarine blue, burnt sienna, and white are blended on the palette to a thick mixture that contains only a bit of water. Then this thick paint is scrubbed onto the peaches with short, back-and-forth strokes of a bristle brush. The dark sides of the forms contain less white. Bare paper peeks through the lighter areas. You can see how the texture of the paper roughens and breaks up the brushstrokes.

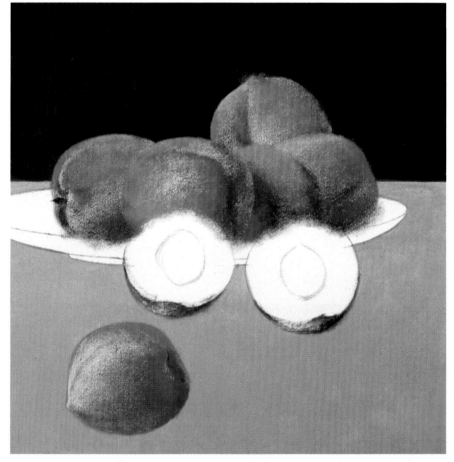

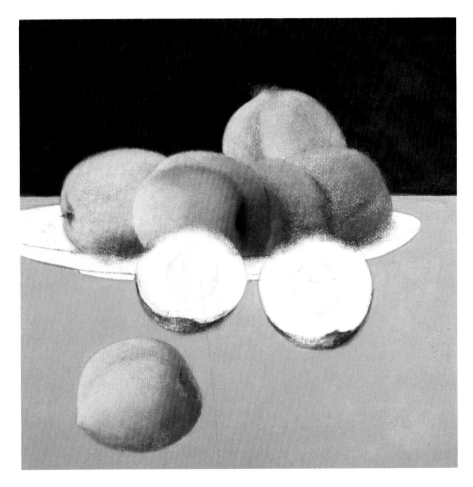

Step 3. The purpose of Step 2 is to establish the pattern of light and shadow on the peaches. Now the same brush and the same short, scrubbing strokes are used to build color over this undertone. When Step 2 is dry, a simple mixture of yellow ochre and white is then scumbled over several of the peaches to suggest a golden tone. The ruddy tone is a mixture of naphthol crimson, cadmium red, a little ultramarine blue, and white. These colors aren't completely opaque; thus the underlying shadowy tone comes through.

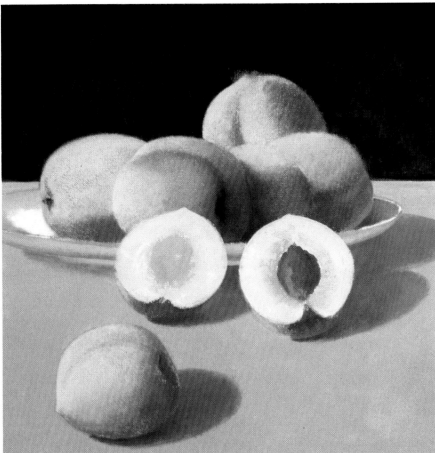

Step 4. The lighter tops of the two peaches to the right are scumbled with this yellow ochre and white mixture. The shadows on the peaches are strengthened with the same mixture used in Step 2. The ruddy tone used in Step 3 is added to the undersides of the two peach halves. The shadows are scumbled with ultramarine blue, naphthol crimson, yellow ochre, and white. Now the juicy insides of the peaches are painted with a round, softhair brush and mixtures of yellow ochre, cadmium red, ultramarine blue, and white.

Step 5. The warm tones of the peaches are now scumbled with a flat bristle brush—a mixture of naphthol crimson, yellow ochre, ultramarine blue, and white. The lighter areas are strengthened with more scumbling strokes of yellow ochre and white. Placed side-by-side, these scrubby strokes of thick color, broken up by the texture of the paper, seem to blend into one another.

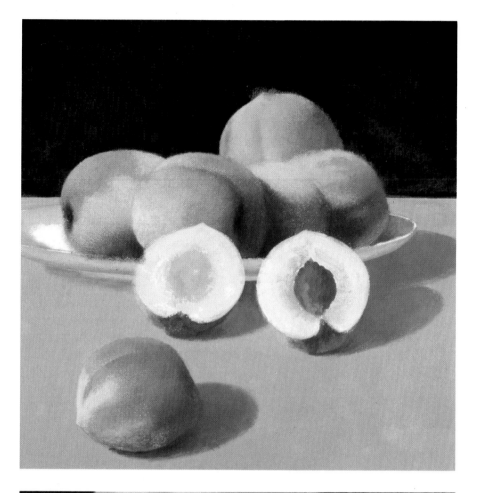

Step 6 (close-up). The precise details are saved for the final stage, as usual. Now the tip of a round, softhair brush picks up fluid color to paint the pit of the peach to the right, plus the juicy fibers of the peach to the left. The darks of the pit are ultramarine blue and burnt sienna. The warm glow around the pit is the same mixture used for the ruddy tones in Step 5. This same warm mixture appears inside the cut peach to the left, with the glistening fibers painted in a pale mixture of yellow ochre and white. The slender, pointed brush is also used to paint the precise form of the plate with the same mixture used for the shadows in Step 4, plus more white.

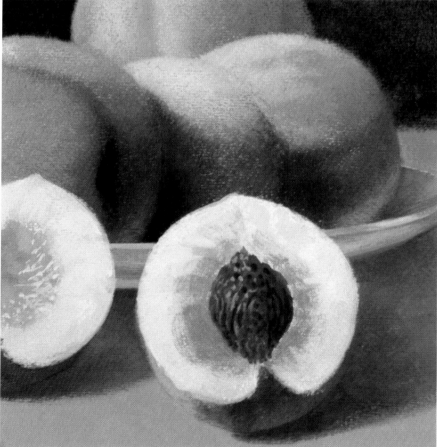

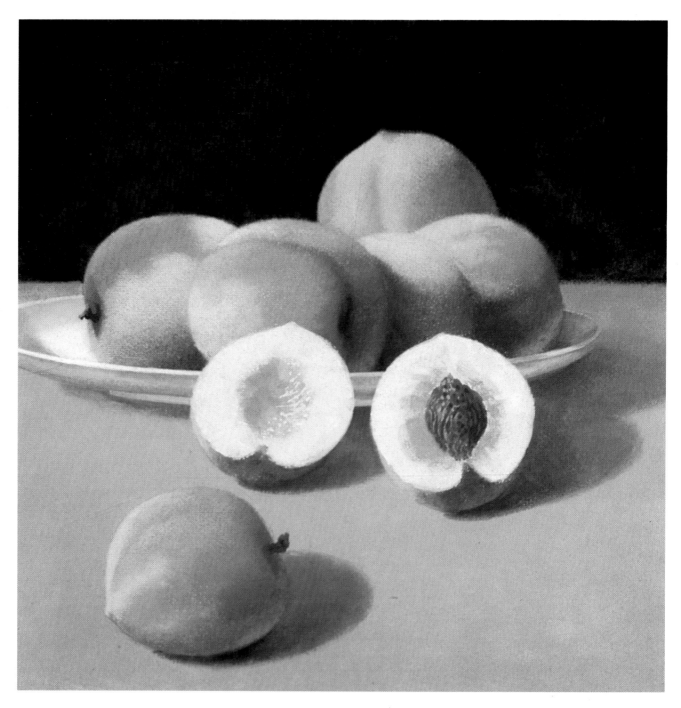

Step 6. Here's the final painting, with all the precise details added with the tip of a round, softhair brush. Dark notes are discretely added to complete the stems of the peaches and to darken the shadows right under the edges of the peaches on the tabletop. Such subtle darks aren't black, but blue-brown mixtures, such as ultramarine blue and burnt umber. Study the brushwork carefully. The beautiful gradations on the peaches *are not* the result of blending one wet color into another, but the result of placing scumbled strokes side-by-side. These ragged, scrubby strokes do overlap just a bit, but they seem to blur softly into one another. The whole trick is to work with thick color and light strokes, gradually laying one stroke over another so that the color builds up gradually.

Step 1. Underpainting and glazing is an old-master technique that takes advantage of the transparency of the acrylic painting medium. To practice this technique, find some common household object like this kettle. This demonstration is painted on a canvas board and begins with a pencil drawing of the intricate forms of the kettle, plus the lines of the tabletop. Then the shadow areas of the kettle and table are painted with a fluid mixture of black, white, and ultramarine blue, diluted with lots of water. A thicker version of the same mixture (less water) is used for the background, which is painted very carefully around the shape of the kettle.

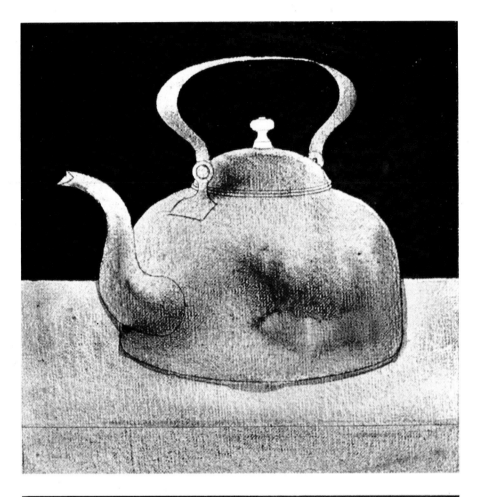

Step 2. The pattern of shadows on the kettle is now painted with the same mixture, but containing much less water so that the paint is really thick and opaque. For the first step, where you're working with very fluid paint, you can use a softhair brush. But now it's best to switch to a bristle brush to carry the thick color of Step 2.

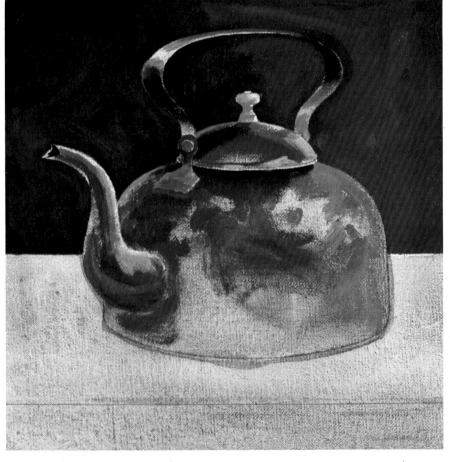

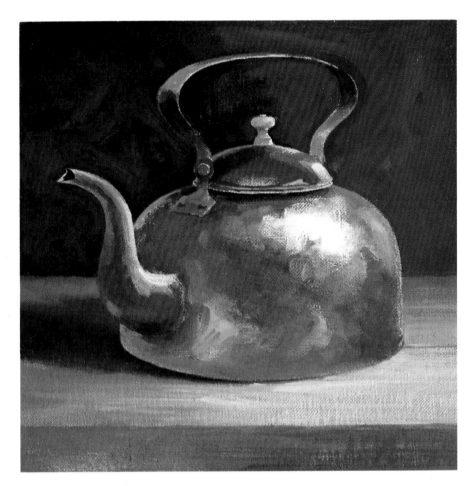

Step 3. The pattern of lights and shadows on the kettle is now completed. A bit more white is added to the same mixture for the middletones. A lot more white is added for the lightest areas. The tabletop is painted with exactly the same mixtures. The shadow that's cast by the kettle is painted with the same dark mixture used in the background. As you can see, the entire picture is painted in monochrome, concentrating only on the pattern of light and shade. Color is saved for the final step.

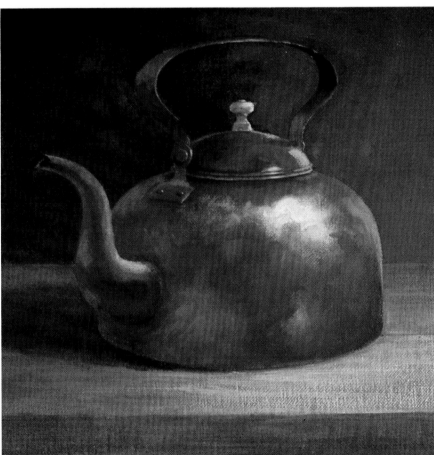

Step 4. A fluid, coppery glaze is mixed on the palette—burnt sienna, cadmium red, yellow ochre, and gloss medium. This luminous, transparent tone is brushed over the entire kettle, which suddenly turns a warm, metallic hue. A few touches of ivory black are added to strengthen the darks on the kettle. A much paler glaze of burnt sienna, yellow ochre, and ivory black—with lots of gloss medium—is carried over the background and the tabletop to add a touch of warmth. The underpainting and glazing technique is extremely useful when you're painting a subject in which the lights and shadows are complicated: first you paint the lights and shadows in monochrome; then you complete the job with colored glazes.

Step 1. To practice rendering textures, find yourself some rough, weathered outdoor subject like this old, dead tree. You'll also find it helpful to paint on a roughly textured surface. This demonstration is done on a sheet of illustration board that carries two coats of thick acrylic gesso applied with a stiff, nylon housepainter's brush that leaves the marks of the bristles in the surface. One coat is applied from top to bottom; the other coat runs from right to left, creating a crisscross texture. The painting begins with a careful pencil drawing, and a transparent sky tone is brushed right over the pencil lines with ultramarine blue, white, just a hint of burnt sienna, and lots of water.

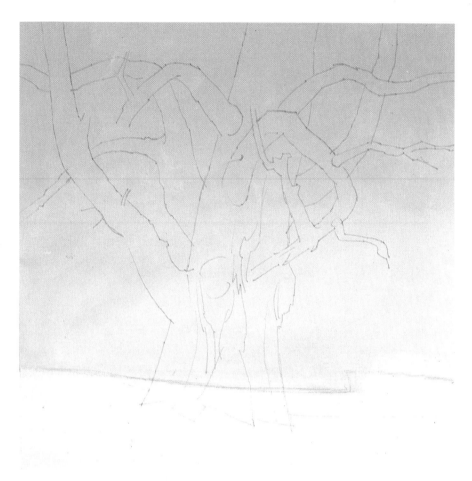

Step 2. When the sky is dry, the tree is painted right over it with a mixture of burnt sienna, ultramarine blue, black, and just a little white. The general shape of the tree is blocked in with a flat, softhair brush; then the lines in the bark are drawn with a pointed, softhair brush. In the lighter areas of the trunk, the brushes are skimmed quickly over the painting surface, hitting just the ridges of the rough gesso to produce a drybrush effect. More pressure is applied, and the color is more fluid in the darker areas. The leaves at the base of the tree are painted with the same mixture, dabbed on with the tip of a filbert.

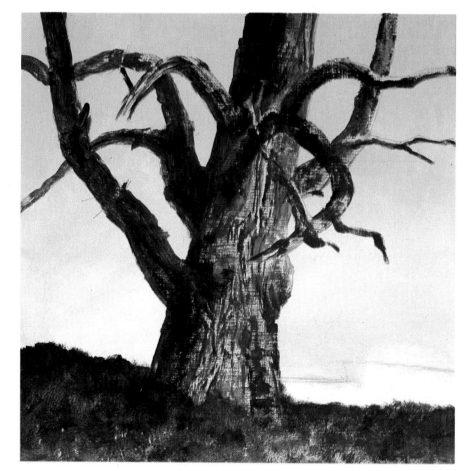

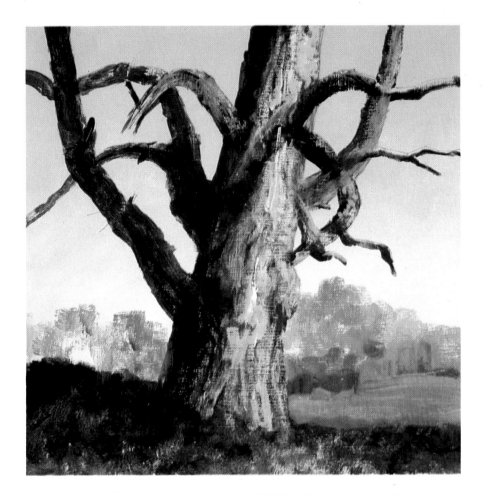

Step 3. Next come the lighter tones on the tree. A bristle brush picks up a thick mixture of burnt sienna, ultramarine blue, yellow ochre, and lots of white—very little water—and drags this mixture over the surface of the rough gesso without pressing too hard. Once again, the texture of the gesso breaks up the strokes into a drybrush effect. The warm tone of the distant trees is a mixture of burnt sienna, yellow ochre, white, just a hint of ultramarine blue, and not too much water. This thick mixture is scumbled over the rough gesso, whose texture comes through once again. The bit of meadow to the right is a more fluid version of this same mixture, with more ultramarine blue and more water.

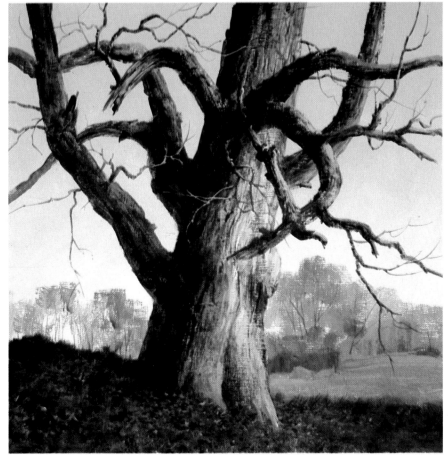

Step 4. The tip of a round, softhair brush adds the twigs and other details of the tree, using the same dark and light mixtures introduced in Steps 2 and 3, but with more water for a precise, fluid stroke. The same mixture and the same brush add some trunks to the distant trees. A transparent glaze of cadmium red, yellow ochre, and water is carried over the leaves on the ground to complete the picture.

Step 1. Now that you've tried out a variety of acrylic painting techniques, it's time to put them to work on a more ambitious still life. A wooden bowl of fruit, with so many different colors and textures, is a good subject. Once again, begin with a careful pencil drawing that defines the outer edges of all the forms. This demonstration begins with a background tone of black, white, and a little yellow ochre, applied with a bristle brush. The strokes are bold and obvious. Notice how the background is darker behind the fruit—to dramatize their shapes and colors.

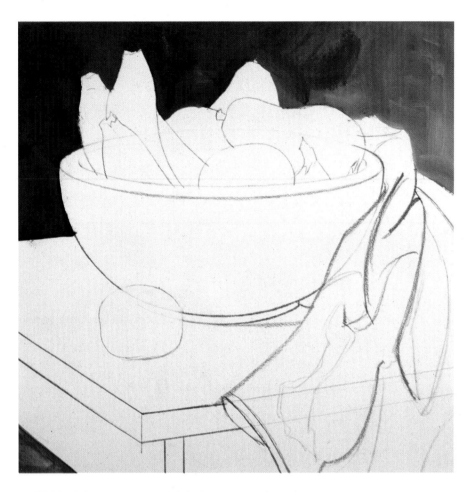

Step 2. The flat tones of the bananas and pears are painted with a smooth, fluid mixture of cadmium yellow, white, and just the slightest hint of ultramarine blue. The plums are painted with slightly thicker color and scumbling strokes, like the peaches in Demonstration 3—a mixture of ultramarine blue, naphthol crimson, and white. The bowl is begun with burnt sienna, ultramarine blue, yellow ochre, and white. A flat, softhair brush is used for all the operations in Step 2.

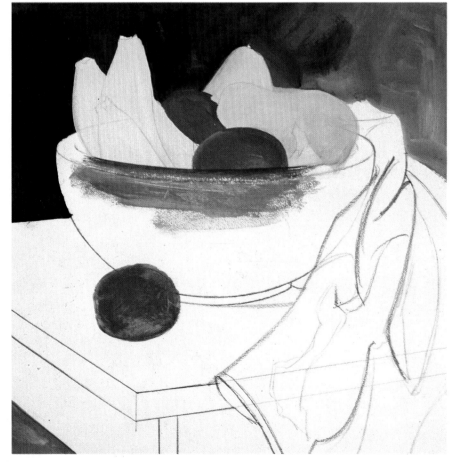

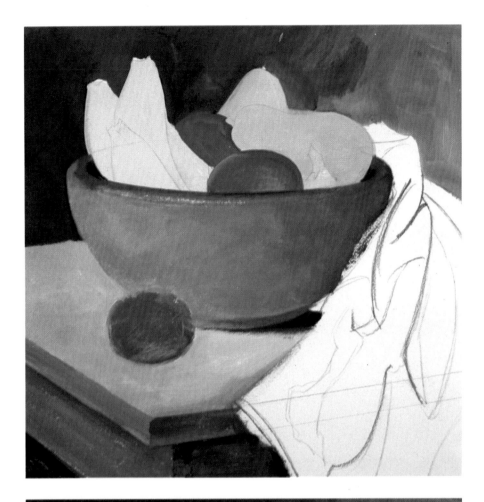

Step 3. The wooden bowl and table are painted with fluid mixtures of burnt sienna, yellow ochre, ultramarine blue, and white, with enough water to produce a creamy consistency. The darks obviously contain more blue and brown. A flat, softhair brush places the wet strokes side-by-side and quickly blends them together before they dry—a technique called wet blending. This kind of brushwork produces a casual, irregular blend in which the strokes are still partly visible—just right for the texture of the wood.

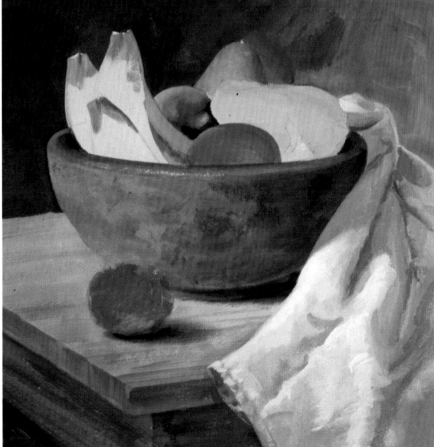

Step 4. The darks of the banana and the shadow side of the more distant pear are painted with touches of burnt sienna, yellow ochre, ultramarine blue, and a bit of white. The warm notes in the pears are burnt sienna, cadmium yellow, and yellow ochre. The grain of the wood is drybrushed with a darker version of the mixture in Step 3— more blue and brown. One plum in the bowl is modeled by scumbling phthalocyanine blue, naphthol crimson, and white. The napkin is painted with form-following strokes of ultramarine blue, burnt sienna, yellow ochre, and white.

Step 5. Now it's time to start refining the forms of the fruit. A round, softhair brush paints the lighted sides of the bananas with yellow ochre, cadmium yellow, white, and just a touch of burnt umber. The shadow sides are scumbled with burnt umber, yellow ochre, ultramarine blue, and white. To make the big pear rounder, the darker tones are scumbled with ultramarine blue, yellow ochre, burnt sienna, and white—with wét, juicy highlights of white and yellow ochre quickly brushed onto both pears when the scumbles are dry. The other plum in the bowl is scumbled with the same mixture used in Step 4, adding a bit more crimson and a lot of white in the highlights.

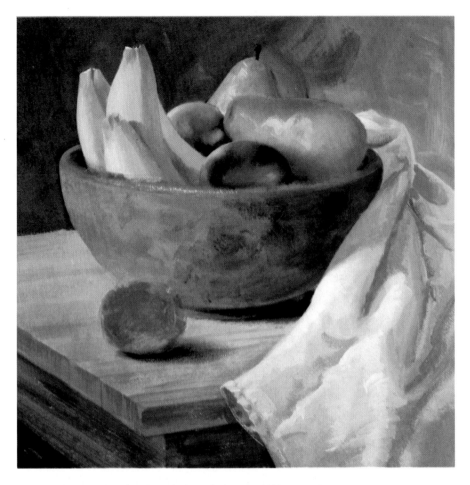

Step 6 (close-up). Here you can see how the finishing touches are added in the final stage. The tip of a bristle brush adds quick dabs of burnt sienna, ultramarine blue, and yellow ochre to suggest the dark spots on the bananas. The point of a round, softhair brush adds the stems with ultramarine blue and burnt umber. Compare the highlights on the pears and the plums. The former are quick, fluid strokes, while the latter are thick scumbles.

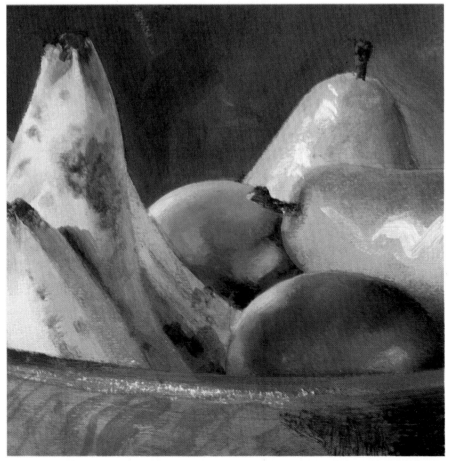

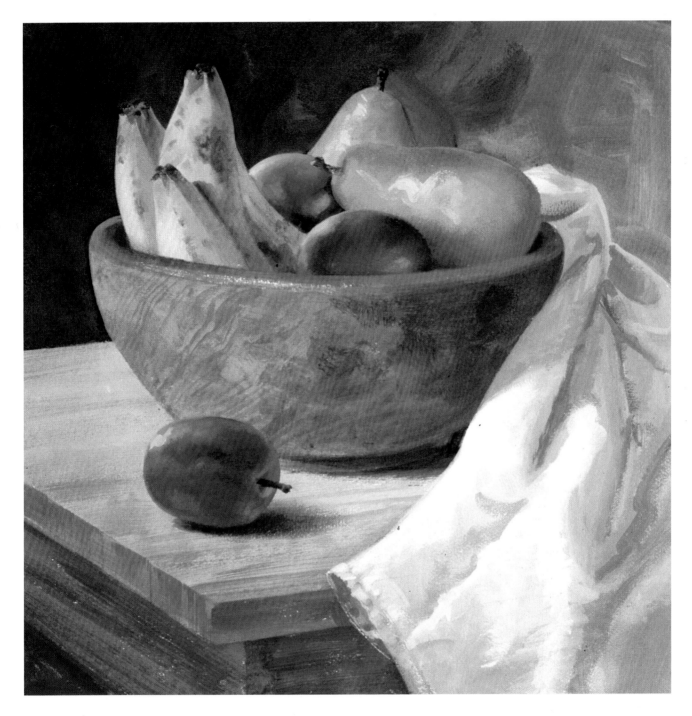

Step 6. A round, softhair brush traces the lines of the grain in the wooden bowl with a mixture of ultramarine blue, burnt umber, and white. The same mixture—and the same brush—add a bit more grain to the table. The plum on the table is modeled by scumbling—the same mixtures as the plums in the bowl. You can see quite clearly that the shadow under the plum is drybrushed with the same colors used on the shadow side of the bowl. By now, you know that there's a logical sequence of operations in all these paintings: covering the shapes with flat tones; modeling the lights and darks over the flat tones; then adding highlights, textures, and details.

DEMONSTRATION 7. FLOWERS

Step 1. For your next still-life project, now try the more complex shapes of flowers, perhaps in a transparent vase—a particularly interesting challenge to paint. You'll need to make a precise pencil drawing of the flowers, leaves, and stems. Pick a simple, geometric vase, nothing ornate. As usual, this demonstration begins with a freely painted background—broad, bristle brushstrokes of ultramarine blue, burnt sienna, black, and a fair amount of white on the right side. This demonstration is painted on a canvas board whose woven surface will soften the strokes.

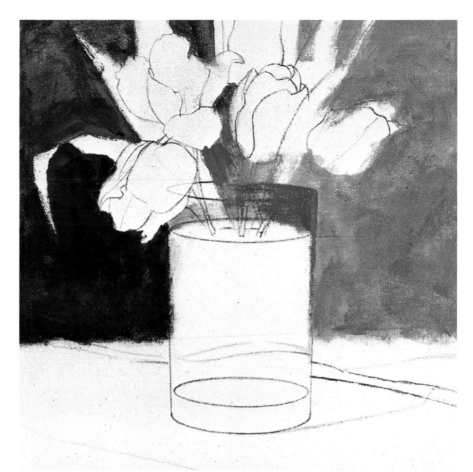

Step 2. The flat undertones of the flowers are painted with liquid color and a bristle brush. The yellow flowers are covered with a shadowy tone of yellow ochre, white, and ultramarine blue; the more brilliant colors will be painted over these muted tones in the later steps. In the same way, the white flower begins as a shadowy tone of ultramarine blue, burnt umber, and white. Only the red flower is painted with its full brilliance, since this will be the brightest note in the picture—a mixture of cadmium red and naphthol crimson, with a touch of ultramarine blue.

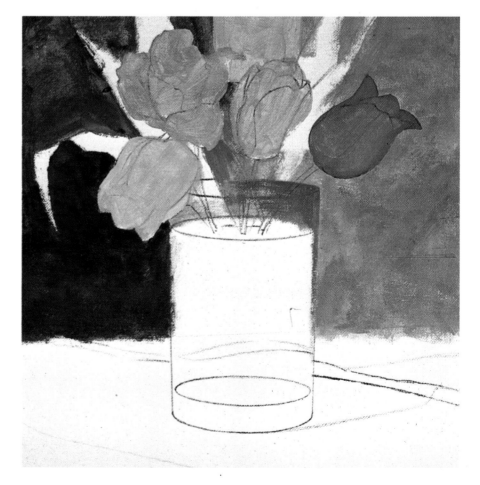

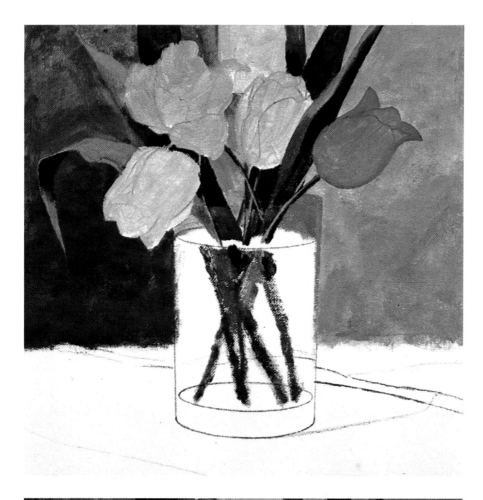

Step 3. The darks of the leaves and stems are painted with a mixture of ultramarine blue, yellow ochre, and burnt sienna. Then the lights are painted right over the darks with cadmium yellow, ultramarine blue, burnt sienna, and white. Inside the vase, notice how roughly the stems are painted, since they'll be partly obscured by the reflections in the glass.

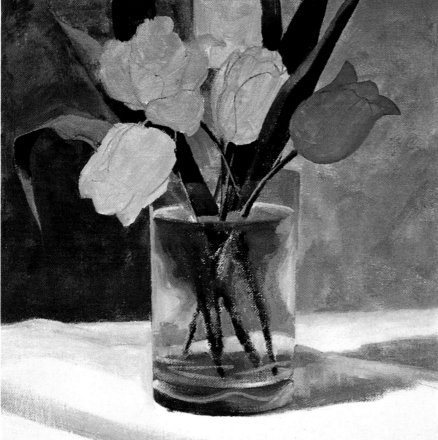

Step 4. Clear glass and clear water have no color of their own, but simply reflect the color of their surroundings. In Step 1, you may have noticed that the color of the background was carried over into the upper portion of the vase. Now the same color is carried down into the water to the very bottom of the vase. The mixtures are the same as the background—ultramarine blue, burnt sienna, black, and white—with more white for the lights and middletones. There's no special trick to painting water or glass; you just have to forget that you're painting a transparent substance and simply paint the patches of light and dark. The same mixtures are used to paint the shadows of the folds in the tablecloth.

Step 5. The dark tones on the yellow flowers are added with a fluid mixture of burnt sienna, yellow ochre, and ultramarine blue, diluted with plenty of water so the color really flows onto the canvas. A flat, softhair brush applies the color very smoothly. The rough brushwork done in the background will now accentuate the smoother brushwork of the flowers and the leaves.

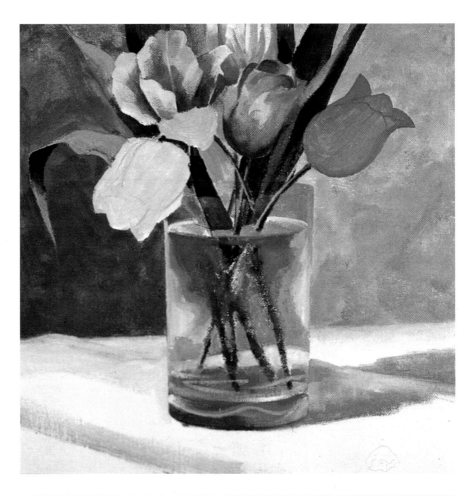

Step 6 (close-up). This "life-size" close-up shows you the modeling on the flowers. The light areas of the yellow flowers are applied with a round, softhair brush carrying a fluid mixture of cadmium yellow, yellow ochre, a little burnt sienna, and white. The edges of the strokes are scumbled, so they seem to merge softly with the shadow tones. Strong darks are added to the undersides of the red and yellow flowers with burnt umber and ultramarine blue. This same mixture, with a lot of water, is used to add some subtle darks to the bright side of the red flower. Observe how the texture of the canvas breaks up and softens the brushstrokes.

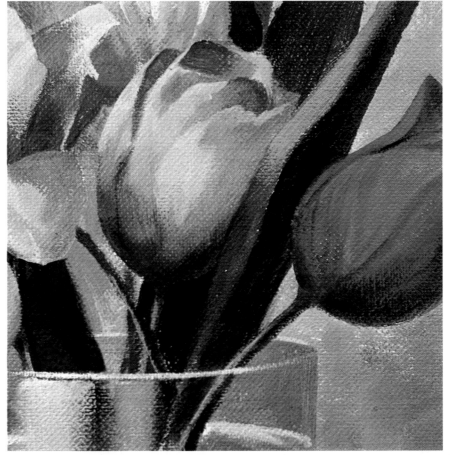

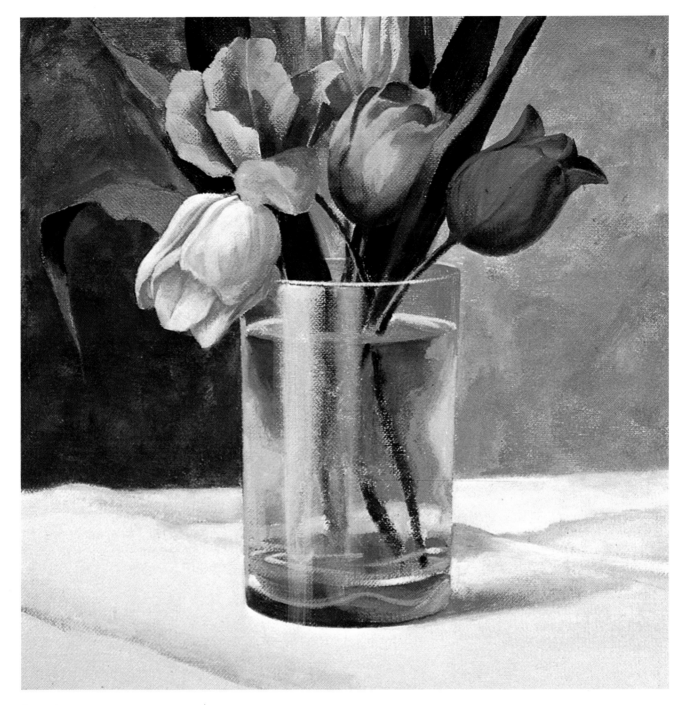

Step 6. In this final stage, the white flower is painted in the same way as the yellow ones. Soft shadows are added with ultramarine blue, burnt sienna, and white. Then the lights are added with almost pure white, faintly tinted with the shadow mixture. The vertical highlights and the bright edges of the vase are painted with this same mixture—mostly white, with just a little burnt sienna and ultramarine blue. The highlights on the glass are painted with just enough water to make the tones translucent so that you can still see the stems within the glass and the background tone beyond. Some of this mixture is brushed into the center of the shadow on the tablecloth, which seems a bit too dark in Step 5. It's worth noting that the bright tones of the flowers look even brighter because they're surrounded by muted colors.

Step 1. Having practiced your basic techniques on several still-life subjects, this is a good time to try a landscape. You can make some sketches outdoors and then go back home to paint your picture from these sketches. Or you can load your paintbox, take along a big plastic bottle of water, and try painting on location. Begin with a pencil drawing of main shapes—trunks, branches, rocks, and the masses of leaves—but don't try to draw every leaf. Here, the sky is painted right over the pencil lines with phthalocyanine blue, ultramarine blue, a little burnt sienna, and lots of white. The mixture contains much water, so the color doesn't completely obscure the pencil lines.

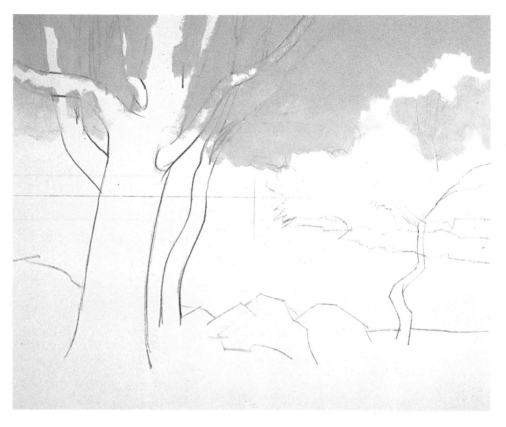

Step 2. The sky mixture is carried down over the water with just a bit more white. Then the trees are painted with short, scrubby strokes of phthalocyanine green, cadmium yellow, a little burnt umber, and white. The distant trees contain more white, while the darker trees on the right contain more green and brown. The reflections in the water are the same mixtures, softened with a bit more brown. The warm strip along the shore to the right is burnt umber, phthalocyanine green, and white. Everything in Steps 1 and 2 is done with the bold strokes of a bristle brush.

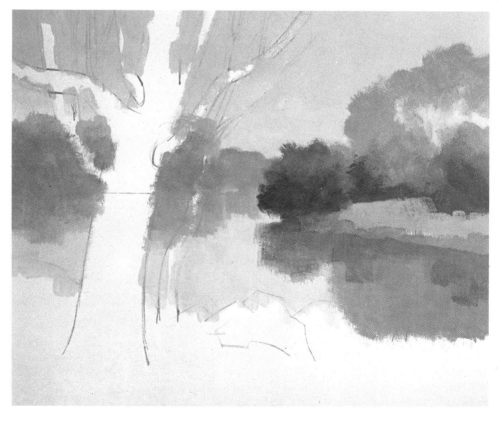

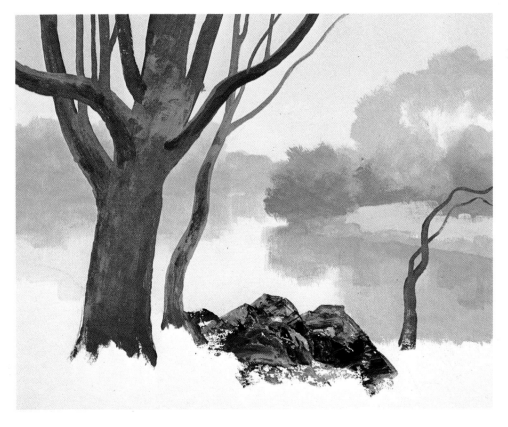

Step 3. Shifting to a flat, softhair brush, the trunks are painted with black, white, and yellow ochre. Notice how the strokes follow the direction of the trunks and branches. The mixture on the palette is thick enough to pick up with a painting knife, which is used to paint the rocks with straight, squarish strokes. The darks of the rocks are painted first; then more white is added to the mixture, and the lighter tones are painted right on top of the darks. The knife strokes are rough and imprecise—just right for the texture of the rocks.

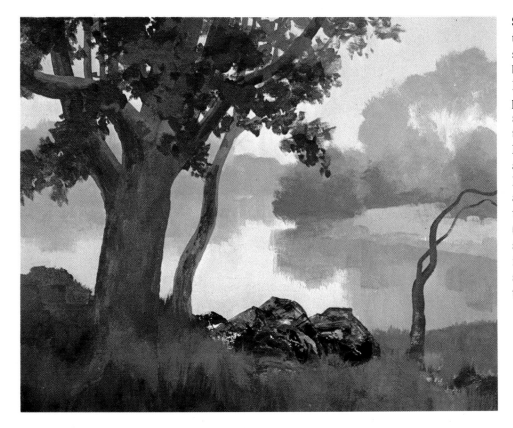

Step 4. The tip of a filbert is tapped against the painting surface—which is illustration board—to suggest clusters of leaves. The leafy tones are phthalocyanine green, burnt sienna, yellow ochre, plus a touch of white for the lighter leaves. The same mixtures are used to paint the darks and lights of the grass. The tip of a round, softhair brush paints the darks first; while these tones are still wet, lighter strokes are painted over and into them. The vertical strokes follow the direction of the grass.

Step 5. Some light tones are added to the trees on the most distant shore—chromium oxide green, ultramarine blue, yellow ochre, and a lot of white—so you can now see a clear division between light and shadow. This same mixture, with a little less white, adds some lighter details to the foliage on the shore to the right. For the light shining on the water, even more white is added to the mixture; now the mixture is fairly thick, and it's drybrushed across the water with the horizontal strokes of a round, softhair brush. It doesn't matter if some of these lines are carried over the trees, which will be darkened in the next step.

Step 6. A transparent glaze of phthalocyanine green, burnt umber, and water is brushed over the trunks and branches. When this is dry, the dark textures of the bark are painted with this same mixture, but containing more brown. Individual blades and clusters of grass are added to the immediate foreground with mixtures of phthalocyanine green, cadmium yellow, and a touch of burnt sienna, plus a little white to make the strokes stand out against the darker background. Touches of richer green are added to the foliage with the tip of a round, softhair brush—mixtures of phthalocyanine green, cadmium yellow, burnt umber, and a little white.

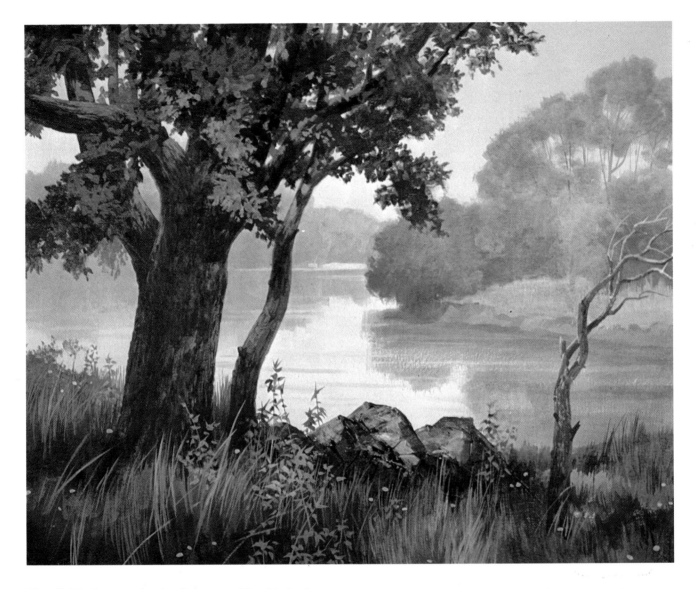

Step 7. The last, precise details are saved for this final step. More blades of grass plus some leafy weeds are added to the foreground with the same mixtures used in Step 6. Notice, however, that the *entire* foreground isn't covered with these strokes; you can still see lots of the broad, rough brushwork from Step 4. A few tiny touches of cadmium yellow suggest scattered wildflowers among the weeds. A few more touches of really bright green—phthalocyanine green, cadmium yellow, and white—are added to the foliage. The small tree to the right is completed with strokes of ultramarine blue, burnt umber, and white. You'll notice a slight change in the color of the trees on the distant shore to the right. They're enriched with a glaze of chromium oxide green, yellow ochre, and water. This transparent tone is carried down over the reflection of these trees in the water to the right. A very fluid, transparent glaze is an almost invisible way to enrich the color of your painting in the final stages.

Step 1. The shapes of the trees, road, and clouds are drawn in pencil. Then the dark trunks are drybrushed with a bristle bright carrying a blackish mixture of ultramarine blue and burnt sienna. The blue patches in the sky are painted with ultramarine blue, yellow ochre, and white. Some burnt sienna is added to this mixture for the shadow areas of the clouds. Then the sunlit edges of the clouds are scumbled with a mixture of white and yellow ochre, connecting the blue and the gray. These cloud tones will flow more softly if you add gloss or matte medium. The white-yellow ochre mixtures carry down toward the horizon; this will add a warm glow to the lower sky.

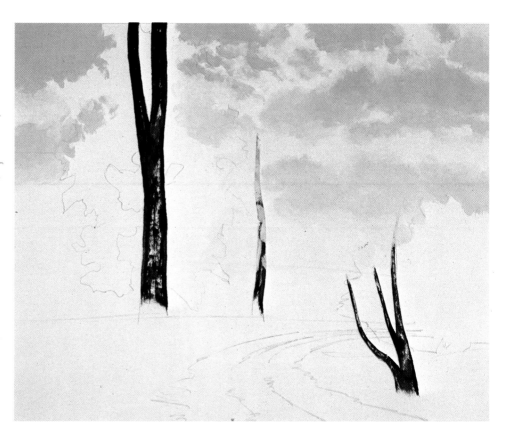

Step 2. The brilliant tones of the autumn trees are painted with scrubby, scumbling strokes of cadmium red and yellow ochre applied with a bristle bright. These slightly ragged strokes suggest the texture of the foliage. The strip of landscape at the horizon is painted with a mixture of ultramarine blue, naphthol crimson, burnt sienna, and white—with a bit less white at the lower edge. The short, stiff bristles of the brush give this shape a ragged edge. Notice that the hot color of the foliage begins to overlap the dark treetrunks, but the color is still quite thin and doesn't obscure the trunks just yet. In later stages, the trunks will begin to disappear under foliage.

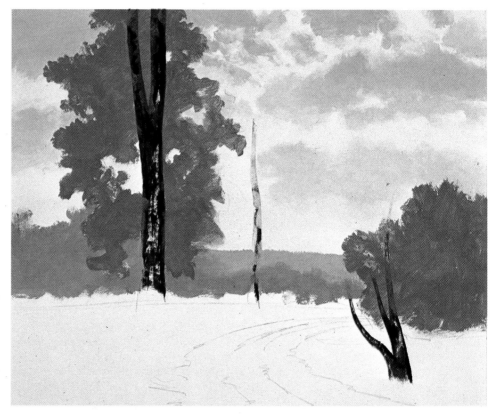

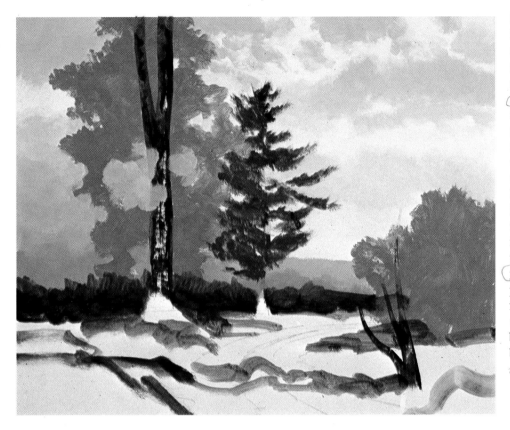

Step 3. The same stiff, short brush scrubs in the foliage of the dark evergreen with ultramarine blue and yellow ochre. At the extreme left, the lower sky is darkened with a thin, fluid mixture of ultramarine blue, burnt sienna, and white, scumbled downward to blur the outline of the distant horizon. Some of the blue sky mixture from Step 1 is painted into the center of the tree to suggest gaps in the foliage where the sky shines through. The dark mass of trees just below the horizon, plus some of the darks in the foreground, are brushed in with a very fluid mixture of burnt umber, ultramarine blue, a little naphthol crimson, and lots of water.

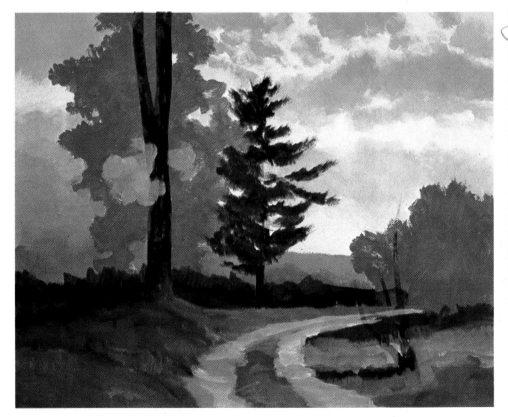

Step 4. The cool tones of the grass are scrubbed in with a bristle bright and a mixture of ultramarine blue, yellow ochre, burnt sienna, and white—with less white in the shadows and more white in the sunlit patches. In the warmer areas, cadmium red is substituted for the burnt sienna. The road is painted with ultramarine blue, burnt sienna, and white, with more blue in the shadows. Notice that the tree in the lower right is beginning to disappear under all that paint; but its shape will be strengthened in the final stages.

Step 5. The lighter trees to the left are brushed in with cadmium red, cadmium yellow, burnt sienna, and white, dabbed onto the illustration board with the tip of a filbert. The shadow tones on the big tree and on the smaller tree to the right are painted with short, scrubby strokes of the same brush—a mixture of ultramarine blue, burnt sienna, and cadmium red. The tones of the foliage are gradually working their way over the shapes of the treetrunks. This same mixture, with more blue, is scrubbed in over the dark strip at the horizon.

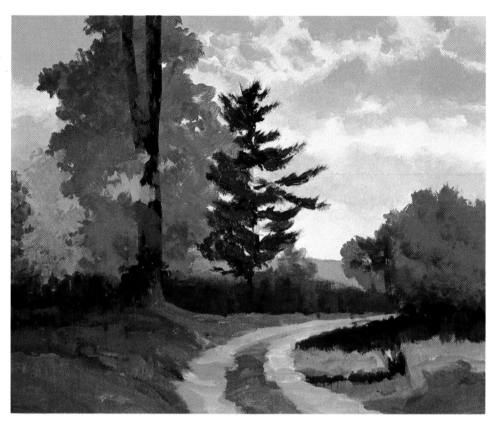

Step 6. The tip of a filbert now adds lighter, sunlit foliage to the trees at the left with cadmium red, cadmium yellow, and yellow ochre. The big treetrunk is now partially covered by foliage. A round, softhair brush adds trunks to the smaller trees at the left and branches to the big tree—a mixture of ultramarine blue and burnt umber. The light edges on the trunks are white with just a hint of burnt umber. A trunk and branches are added to the evergreen with the same dark mixture, which is also used to reconstruct the tree at the right. Then the light foliage mixture is scattered across the right with taps of the filbert.

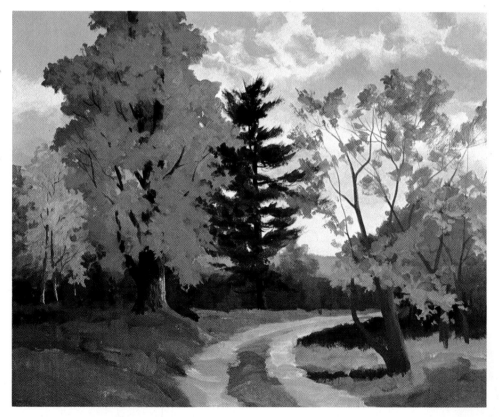

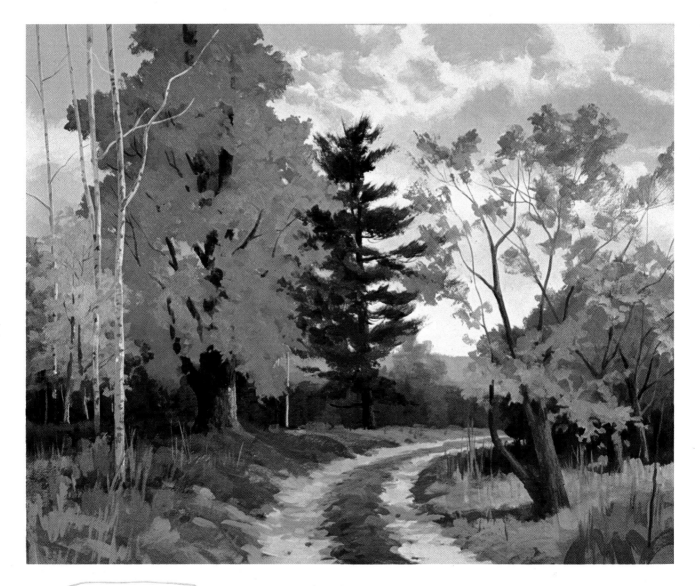

Step 7. Clumps of dead weeds are suggested in the foreground with a round, softhair brush. These strokes are all mixtures of ultramarine blue, burnt sienna, yellow ochre, and white, with more brown in the warmer strokes, more blue in the cooler strokes, and more white in the paler tones. The very tip of the brush uses the pale mixture to indicate individual blades of dried grass. The pale trunks of the birches at the left are painted with two mixtures: white with a faint tinge of burnt umber on the sunlit side; burnt umber, ultramarine blue, and white on the shadow side—with a darker version of this same mixture for the flecks on the bark. This dark mixture is also used to add dark edges to the trees and branches on the right. The somber, grassy tones in the center of the picture, running up the road and reappearing under the evergreen, are ultramarine blue, yellow ochre, white, and an occasional hint of burnt sienna. Although the painting seems to be full of rich detail, the entire landscape is very loosely painted. It's hard to pick out a single leaf— the leaves are just rough touches made by the tip of the brush. Although the ground *seems* to be covered with withered weeds and grasses, only a few individual blades are suggested by the brush.

Branches

Summer Tree (close-up). It's interesting to compare the brushwork used to render the trees on this page and on the facing page. In both cases, the general shapes of the trunks, branches, and masses of leaves are blocked in with broad strokes of a large, flat brush. But then this summer tree is completed with small, precise strokes made by the tip of a round, softhair brush. Short, slender strokes follow the trunk upward and then curve to follow the branches. The leaves are painted with rapid touches of the tip of the round, softhair brush, which is quickly pressed against the painting surface and then pulled away. These touches gradually add up to clusters of leaves. The dark leaves are painted first and then allowed to dry. Then the sunlit leaves are painted right over them, so the brighter clusters seem to come forward into the sunlight, and the darker ones seem to recede into the shadows. But how precise is this brushwork, really? Each leaf is nothing more than a rough dab of paint deposited by the tip of the brush. You can't find a single leaf whose shape is painted with scientific precision. This tree may be painted with small strokes, but the brushwork is still loose and suggestive.

Autumn Tree (close-up). The brilliant colors of this tree are painted entirely with very broad, rough strokes. In fact, the color is scrubbed on so freely that one stroke seems to merge with the next—it's difficult to decide where one stroke begins and another ends. The artist focuses on the overall shape of the tree. He distinguishes between the sunlit foliage and the shadowy foliage but makes no attempt to suggest individual leaves. The same is true of the evergreen to the right, where you see clusters of foliage, but not a single needle. The detailed, precise brushwork is restricted entirely to the slender lines of the branches. Why choose precise brushwork for one painting and rough brushwork for another? Both kinds of brushwork are equally effective. There are no "rules." However, the precise, detailed brushwork of the summer tree works well because it contrasts with a very simple background. If the dense mass of autumn trees were painted with so many tiny strokes, there would be more detail than the viewer could stand—so simpler brushwork is often the best way to paint a complex subject.

Step 1. The key to this stark winter landscape is the pattern of the dark trunks and branches. So the preliminary pencil drawing defines these shapes very clearly, tracing the outline of every trunk and branch. The outer edges of the snowbanks are drawn more simply. The outer and inner shapes of the stream are drawn carefully, although these will change somewhat in the process of painting. Then the darks of the trees are painted in pure black, with a round, softhair brush. The idea is to make these very important shapes dark enough so that they won't disappear as colors are applied behind and around them.

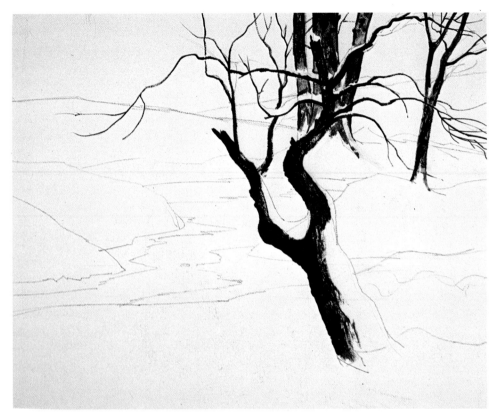

Step 2. The sky is painted with broad strokes of a bristle brush. The tone is a mixture of ultramarine blue, cadmium red, yellow ochre, and white. Since water most often reflects the color of the sky—and ice is just another form of water—the sky mixture reappears along the edges of the frozen stream. The sky tone overlaps the darks of the distant trees, but the trees are still there. The muted tones of the trees along the horizon are now scrubbed in with burnt umber, ultramarine blue, and white. This painting is on a canvas board, selected so that the texture of the weave will soften and blur the brushstrokes.

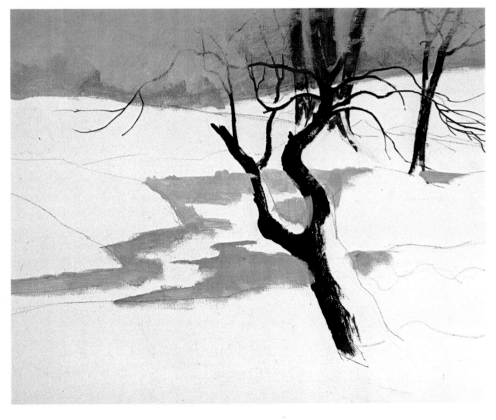

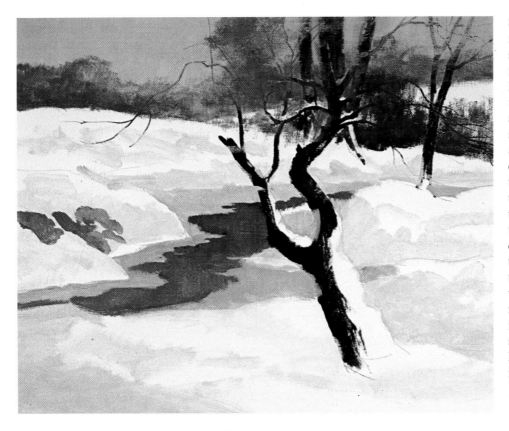

Step 3. The trees at the horizon are extended upward with scumbling strokes of the sky mixture—containing much less white. Then the warmer tree tones—below the horizon and to the right—are scumbled in with burnt sienna and black. For both these operations, the paint is fairly thick and a bristle brush is used. You can see where the texture of the canvas breaks through the strokes. An even darker version of the sky mixture is painted across the center of the stream. And a paler version of that mixture—more white and more water—is used to block in the shadow sides of snowdrifts. Snow, like ice, is just water, reflecting the color of the sky.

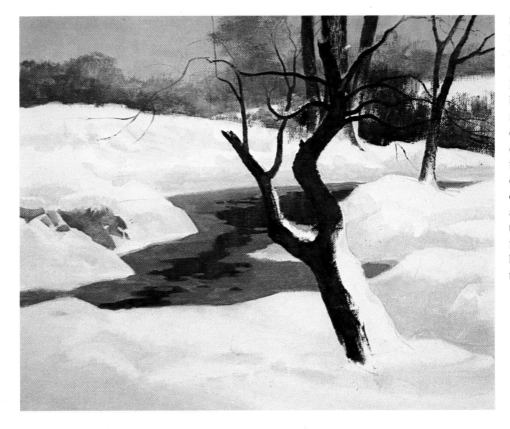

Step 4. The lighted tops of the snowdrifts are scumbled with fluid white, faintly tinted with naphthol crimson, yellow ochre, and ultramarine blue. These scumbled strokes seem to blend into the shadows. A round, softhair brush defines the dark shape within the frozen stream—an even darker mixture of the sky color. The darks of the trees are reinforced now with burnt umber, ultramarine blue, and white. A bit of white is drybrushed over the distant trunks.

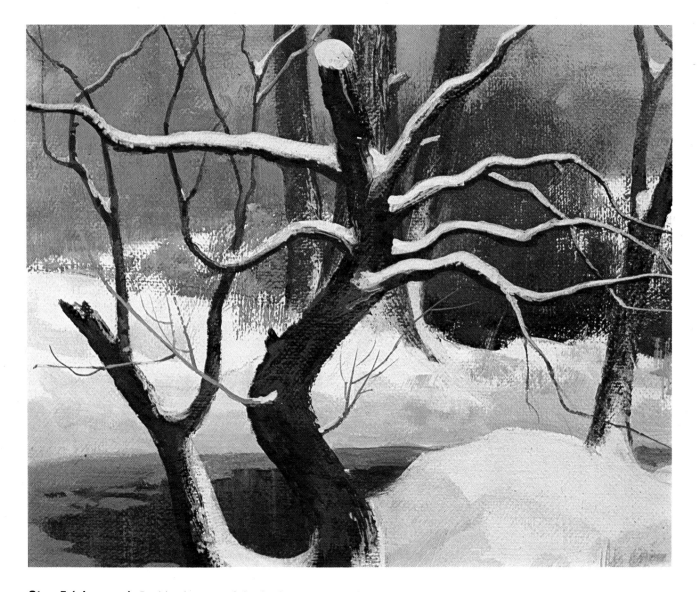

Step 5 (close-up). In this close-up of the final step, you can see how the trunks and branches are completed with two drybrush operations. Over the dense black of Step 1, a slightly paler tone of burnt umber, ultramarine blue, and white is drybrushed to suggest the texture of the bark. Then the snow is drybrushed over the edges of the dark trunks and branches—mostly white, with just a tinge of the snow mixture used in Step 4. This section of the painting is shown the actual size of the original so that you can examine how the texture of the weave influences the brushwork. The canvas makes it easier to scumble and blend the smoky tones in the distance. And the weave also makes it easy to drybrush the bark textures on the trunks and branches.

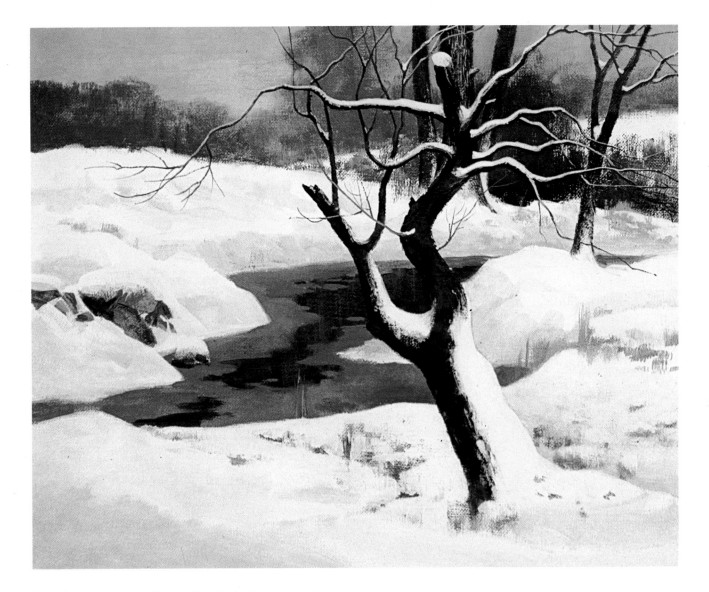

Step 5. Just a few details are added in the final stage. Some warm strokes are added to the lower sky; horizontal strokes of naphthol crimson, yellow ochre, ultramarine blue, and white. All the dark trunks and branches are reinforced with burnt umber, ultramarine blue, and white. The lighted tops of the snowdrifts are reinforced by scumbling a bit more of the mixture used in Step 4. Some shadows are added to the rocks at the left—partly concealed by snow—with burnt umber and ultramarine blue. Here and there, the point of a round brush adds some dead leaves with burnt sienna, a little black and white, and enough water to make the strokes more fluid. Don't make the mistake of thinking that a winter landscape is all dull gray and white. As you see here, winter is full of subtle color.

Step 1. This demonstration shows how to use acrylic in a fluid, transparent technique that's similar to watercolor. The shapes of this rocky coastal scene are drawn with a pencil on cold-pressed (called "not" in Britain) watercolor paper. Then the entire sky area is brushed with clear water—you can use a large, flat brush or a sponge—and the water is allowed to sink in for just a moment. While the paper is still wet and shiny, the dark shapes of the clouds are brushed onto the wet surface with a mixture of ultramarine blue, naphthol crimson, and yellow ochre. The strokes spread and blur. If any color goes where you don't want it, you can blot it up with a paper towel or tissue.

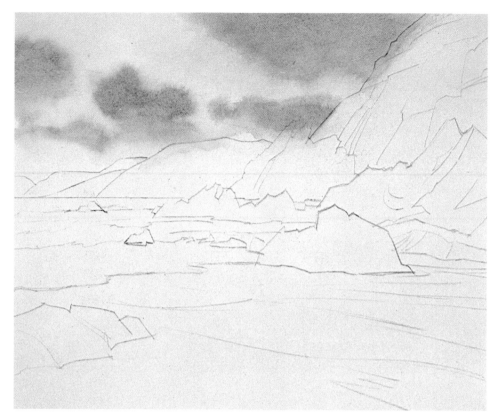

Step 2. The cloud shapes are allowed to dry. Because acrylic is waterproof when it dries, the clouds won't dissolve when more color is brushed over them. Now the sky area is brushed with clear water once again. A pale mixture of ultramarine blue and phthalocyanine blue—with lots of water—is brushed over the entire sky area, right down to the horizon. The color is carried over the distant hills. While the sky is still very wet, a hint of yellow ochre is brushed between the horizon and the lower clouds to add a suggestion of warmth. Notice that no white is used to make the colors lighter. It's all done with water; thus the colors remain transparent, like watercolor.

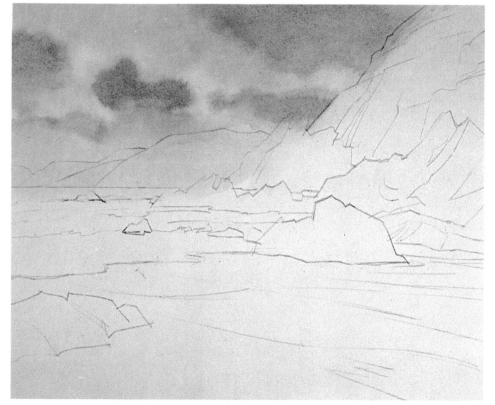

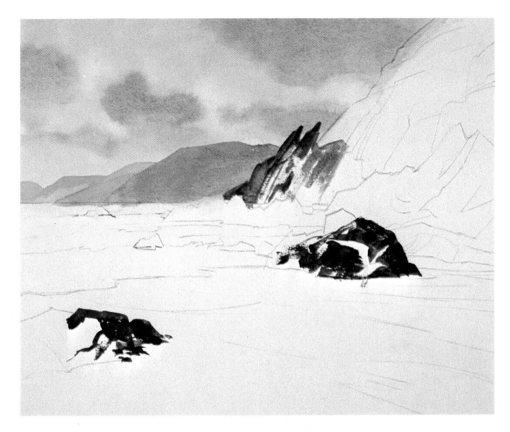

Step 3. When the sky is bone dry, the distant hills are painted over it with the same mixture as was used for the clouds. The paler hills are painted first, then allowed to dry. The darker tones of the cliff and the foreground rocks are begun with the sky mixture, containing more blue and with burnt umber added. The dark side of the big rock is carefully painted around the shape of the gull. Like a watercolor, this entire picture is painted with only softhair brushes.

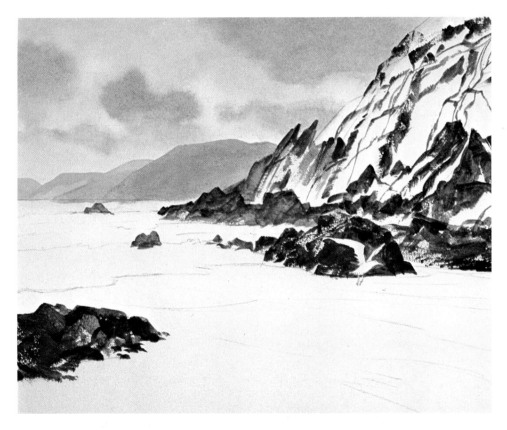

Step 4. More darks plus some details of cracks and crevices are added to the cliffs and rocks with the same mixture used in Step 3. Notice how drybrush strokes accentuate the craggy texture of the rocks. The details of the rocks are painted with great care and allowed to dry. They're now waterproof, so wet tones can be washed over them.

Step 5. A fluid wash of ultramarine blue and burnt sienna is brushed over the entire cliff area. While this tone is still wet and shiny, the dark rock mixture is blended in at the top of the cliff; thus this looming rock formation becomes more shadowy. The tip of a round brush carries slender, curving strokes of the cloud mixture across the water. This same brush draws slender lines of burnt sienna and ultramarine blue across the beach to suggest ripples in the sand. The beach in the immediate foreground is first sponged with clear water and then the ripples are painted onto the wet surface, where they tend to blur.

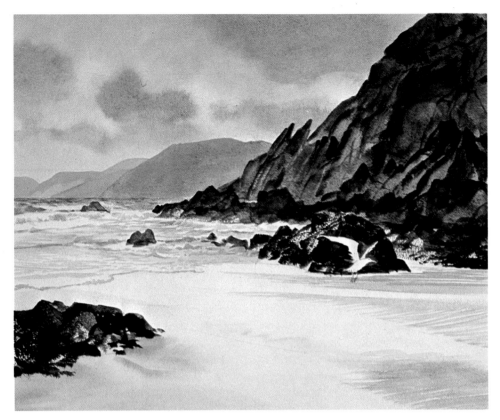

Step 6 (close-up). In the final stage, the rocks at the foot of the cliff are darkened with a wash of burnt sienna and ultramarine blue. The brushwork is interesting. Notice how the lower edges of the rocks are drybrushed so they seem to disappear into the foam of the breaking waves. Drybrush strokes also suggest the rough texture of the rocks in the lower right section. The dark flecks in the distant hill are a phenomenon called granulation, which adds to the atmospheric feeling: a very wet wash of acrylic color, diluted with lots of water, settles into the valleys of the textured paper.

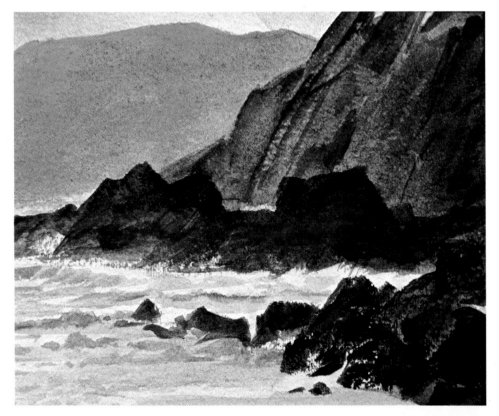

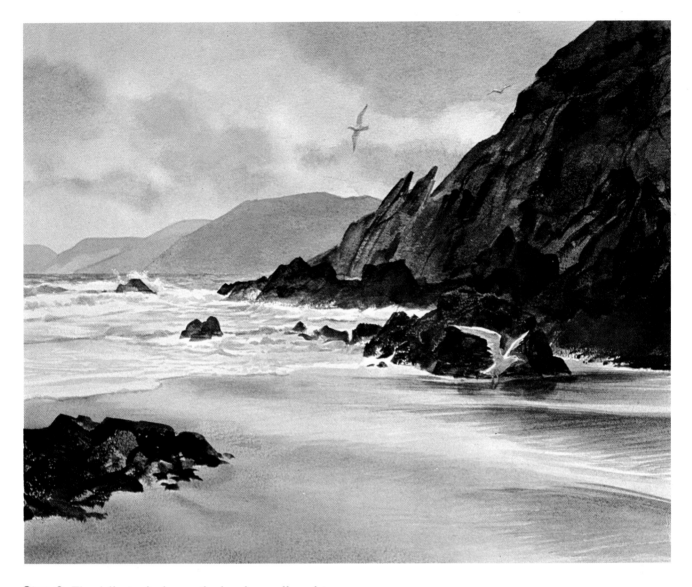

Step 6. The delicate ripples on the beach are allowed to dry. Darker strokes are added on the right to accentuate the ripples—a mixture of burnt umber and ultramarine blue. This same mixture adds reflections beneath the rocks and cliff at the right. And a paler version of this mixture adds the shadows under the wings and body of the gull. When this detailed work is dry, the entire beach is brushed with clear water once again. While the surface is wet, a mixture of burnt sienna, ultramarine blue, and yellow ochre is brushed over the foreground, fading away into the distance. Before the beach loses its shine, a paper towel blots up a light path from the lower right to the edge of the water, suggesting sunlight reflecting on the wet beach. For dry-brush strokes like those on the rocks, one good trick is to work with the side of a round, softhair brush, not with the tip. The side will make a more ragged stroke.

Step 1. For the soft, luminous flesh tones of the human head, canvas is the ideal painting surface. This portrait begins with a meticulous pencil drawing on tracing paper. The back of the sheet is then covered with pencil, and the sheet is laid over the canvas. The lines on the front of the sheet are retraced with a sharp pencil so that they're automatically transferred to the painting surface. A bristle brush paints a background tone around the edge of the face to define the contours. This is a mixture of cadmium red, yellow ochre, and ultramarine blue. The paint is diluted with gloss medium to make it flow smoothly. The darkest shadows on the face are added with touches of burnt sienna, ultramarine blue, and white.

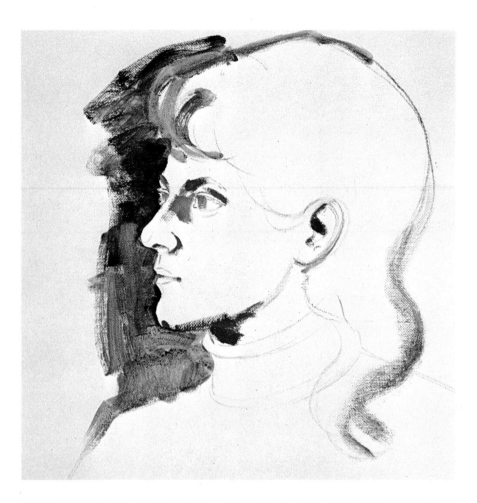

Step 2. The shadows around the features are painted with a small, flat, softhair brush with a creamy mixture of cadmium red, yellow ochre, ultramarine blue, white, and gloss medium. The shadow under the neck is painted with this mixture. The hair is covered with a mixture of burnt sienna, ultramarine blue, yellow ochre, and gloss medium—the long, rhythmic strokes following the direction of the hair. This mixture also suggests the curving shadow on the collar. The lips are painted with a flat tone of cadmium red, burnt umber, and white.

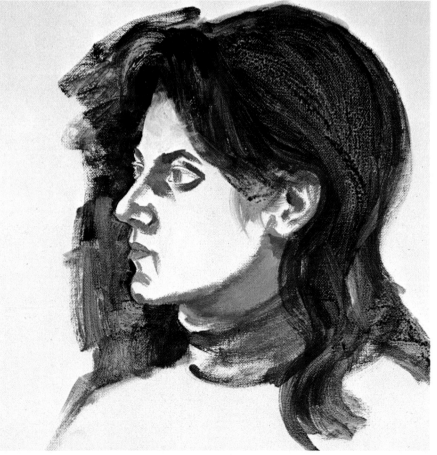

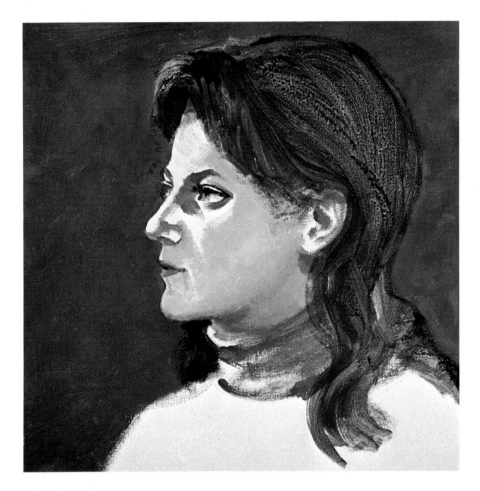

Step 3. A bristle brush paints the middletones of the face with the same mixture used to paint the shadows around the features in Step 2—but with more white. This mixture is scumbled over the shadow on the neck. The eyes are darkened with burnt umber and ultramarine blue. Now the entire head is surrounded with a background tone of phthalocyanine blue, burnt umber, black, and white, so that the head stands out boldly from the background. The brightest areas on the forehead, nose, cheeks, and ear are still bare canvas.

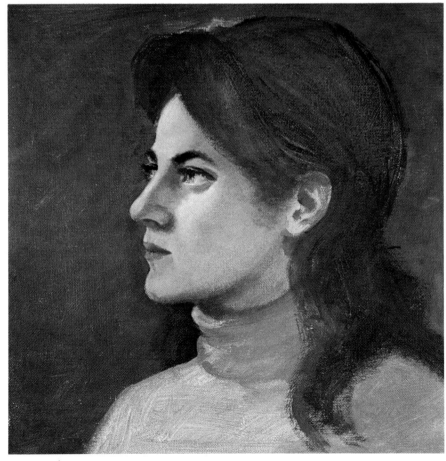

Step 4. With more white added, the same mixture is scumbled over these light areas with a bristle brush, which blends the lights into the middletones. Then a darker, warmer version of this mixture—more red and yellow, less white—is scumbled over the middletones that were originally painted in Step 3. A still darker version of this mixture, with a bit more blue, reinforces the darks around the nose, eyes, jaw, and ears. A deeper tone of ultramarine blue, burnt sienna, and yellow ochre is brushed over the hair. A thin tone of ultramarine blue, naphthol crimson, and white covers the blouse.

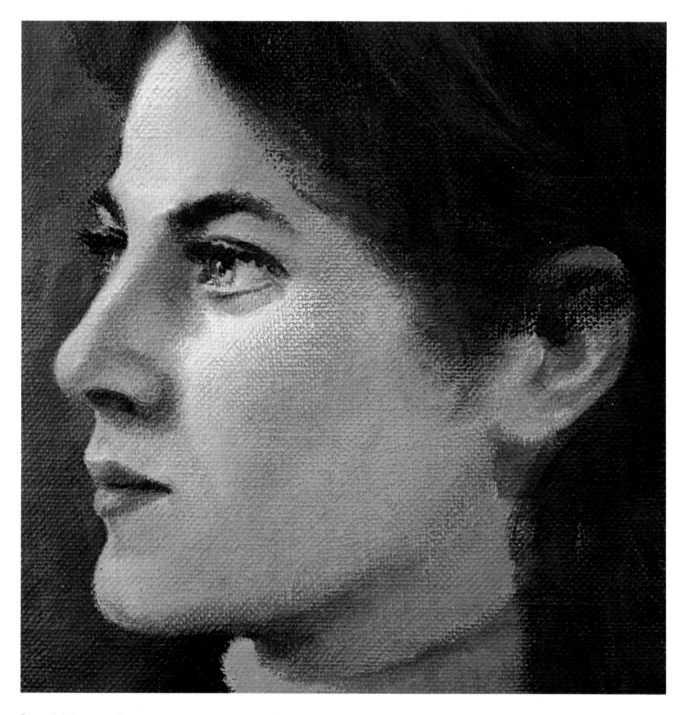

Step 5 (close-up). In the final stage, a flat, softhair brush skims gently over the entire face, softening and enriching the tone. A very pale version of the skin tone, with lots of white and gloss medium, is gently drybrushed over the fore-head, the forward edge of the nose and upper lip, and the lighted area of the cheek. More of the warm flesh tone—introduced in Step 4—is drybrushed over the side of the nose, forehead, and cheek to strengthen the contrast be-tween the light and shadow sides of the face. Where it over-laps the brow and cheek, the soft line of the hair is drybrushed to melt away softly into the skin. Drybrushing makes the lips rounder too.

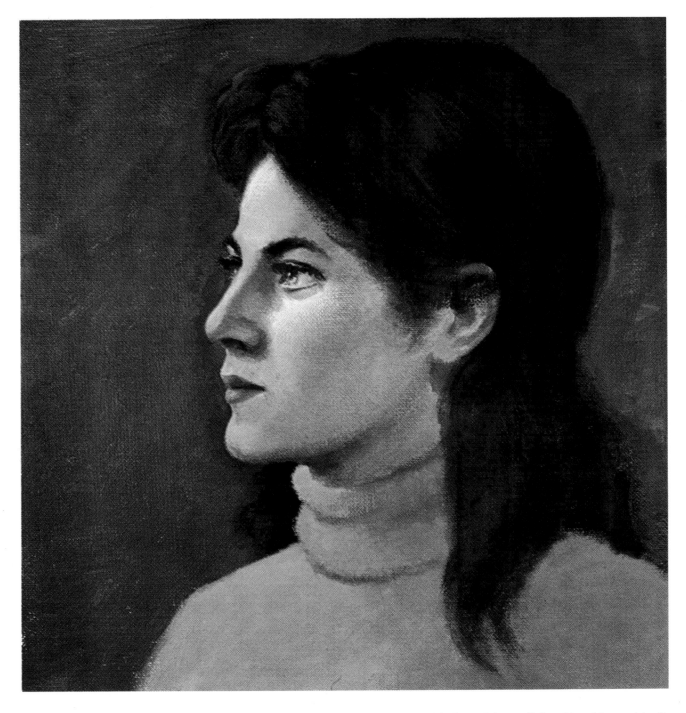

Step 5. Here's the completed portrait. If you compare the final step with Step 4, you'll see that the entire head is rounded and softened with repeated drybrushing. The lights are even lighter, while the middletones are warmer and darker. All the flesh tones are painted with the same palette, with more white in the lights, more red and yellow in the middletones, and a bit more blue in the darks. The shape of the hair is covered with a mixture of burnt umber, ultra-marine blue, black, and just a little white. More white is added to this mixture for the lighter strokes in the hair. The blouse is now covered with a thick, opaque mixture of ultra-marine blue, alizarin crimson, yellow ochre, and white—with more blue in the darker areas to the right and in the lines around the turtleneck. Finally, the background is warmed with a transparent glaze of yellow ochre diluted with gloss medium and water.

DEMONSTRATION 13. MALE HEAD

Step 1. Like the female head in the previous demonstration, this male head is first drawn on tracing paper and then transferred to canvas by the same method. The first painting operation is to establish the strongest darks in the head. The shadows around the eyes are painted with a dark mixture of raw umber, black, and white, applied with a bristle brush.

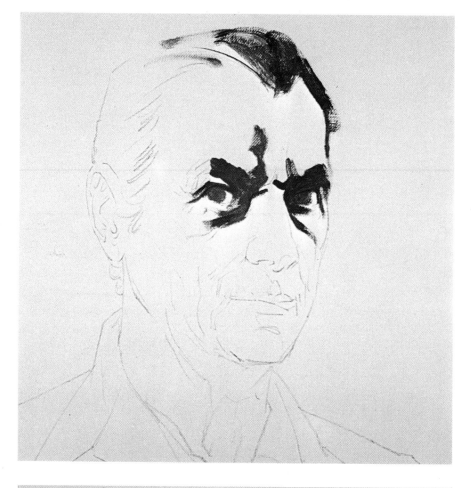

Step 2. The major dark notes of the head are now completed with the same mixture. The edges of the face and shoulders—where they meet the background—are also defined with dark lines. As the shapes of the face, shoulders, and background are filled with color in later stages, these dark lines will tend to disappear. The broad shadow under the chin contains just a bit more white.

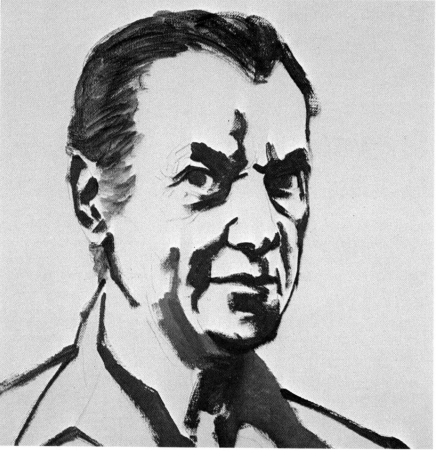

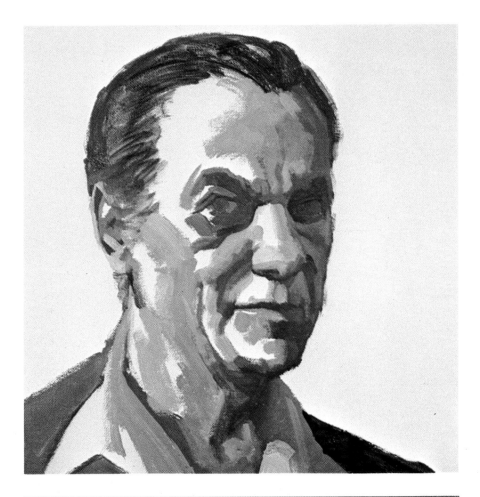

Step 3. More white is added to the same mixture to paint the middletones—the tones that are lighter than the shadows but darker than the lights. You can see where these middletones are added between the darks on the forehead, eyes, nose, ears, cheeks, chin, jaw, and neck. Gaps of bare canvas are left for the lightest tones, which will come next. More dark strokes are added along the right side of the forehead and jaw. The shadows of the features are reinforced with more darks too. And the shoulders are painted with flat tones.

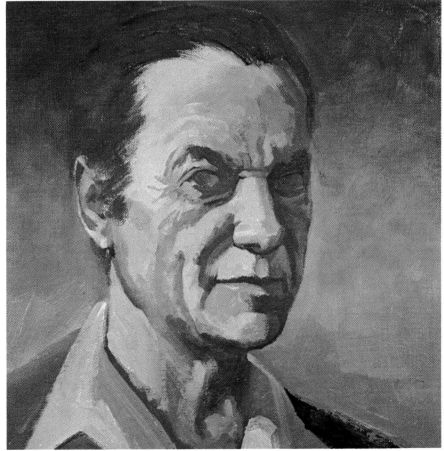

Step 4. Now the lightest tones are scumbled in with the same mixture, which now contains much more white. You can see these tones where there was just bare canvas in Step 3: the left side of the forehead, cheek, nose, upper lip, jaw, neck, and Adam's apple. The shapes of the ear are more clearly defined with this light tone too. A dark version of this mixture covers the hair. The background is painted with various tones of this mixture—darkest at the top, lighter at the middle, then darker again at the bottom—blended by scumbling. The broad tones are all painted with a bristle brush. Then a round, soft-hair brush adds a few more details, such as wrinkles around the eyes.

Step 5. Small bristle brushes strengthen the lights and darks, still working with lighter and darker versions of the same mixture used in all the preceding steps. You can see where strong highlights are added to the brow, nose, and chin, while the darks are strengthened on the right side of the face and neck. The shadow inside the collar is strengthened too. The background is lightened with more scumbling strokes to make the head stand out more boldly. Then the tip of a small, round, softhair brush sharpens the details of the eyes and eyebrows, defines the mouth more clearly, and adds light and dark lines to the hair. At this point, the picture is completely painted in monochrome, like the kettle you saw in Step 3 of Demonstration 4.

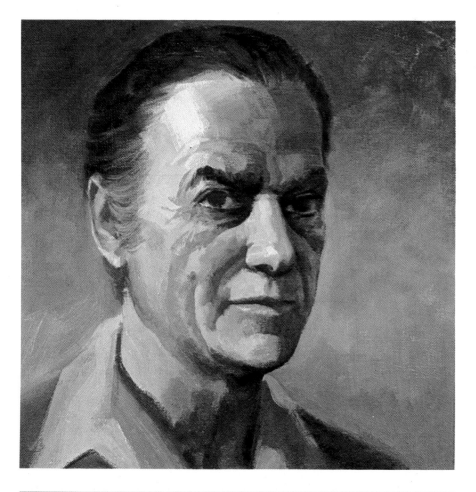

Step 6. The lights and shadows of the head are completely defined. The portrait is already a convincing likeness—like a black-and-white photograph. Now the color is added in transparent glazes that reveal the underlying pattern of lights and shadows. The glazing begins on the face with very pale tones of burnt sienna and yellow ochre, plus a lot of gloss medium—paler in the light areas, darker in the shadow areas. The background is slightly toned with a glaze of naphthol crimson, ultramarine blue, yellow ochre, and gloss medium. The glazing operation is performed with flat, softhair brushes. The whole idea is to build up the color very gradually, so it doesn't obscure the monochrome underpainting.

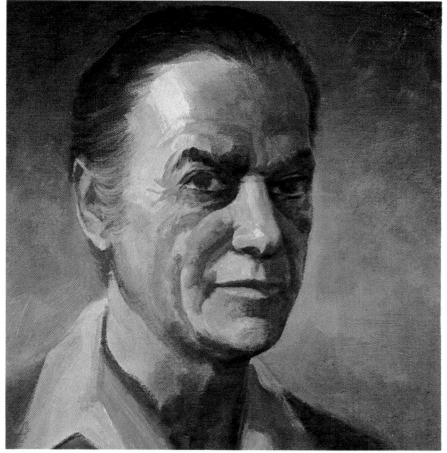

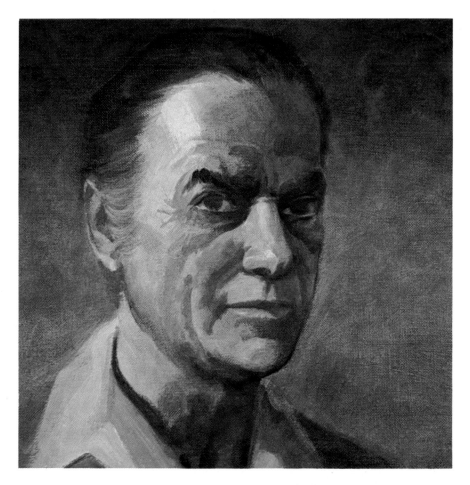

Step 7. When the first glazes are dry, the middletones and shadow areas of the face are darkened with more of the same mixture. The glaze is heavily applied in the shadow areas, a bit thinner in the middletones, and skimmed very lightly over the more brightly lit areas. The lines in the face are darkened with the same mixture, applied with a round, softhair brush. The background is darkened with a glaze of alizarin crimson, yellow ochre, and black, which is carried over the shoulders.

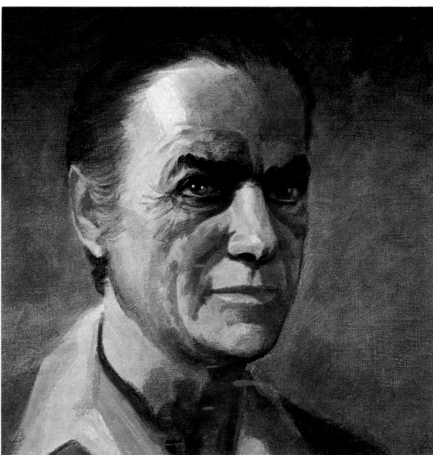

Step 8. When the glazes in Step 7 are dry, the darker tones of the face are strengthened with a mixture of black, burnt sienna, and yellow ochre. A bit more burnt sienna and yellow ochre are glazed over the lighter areas. Now the face begins to glow with the colors of life. The whites of the eyes are lightened with a whisper of white and ultramarine blue diluted with a lot of medium, while highlights are added to the eyes with the same mixture diluted with much less medium. The background is darkened with a glaze of ultramarine blue and a little yellow ochre.

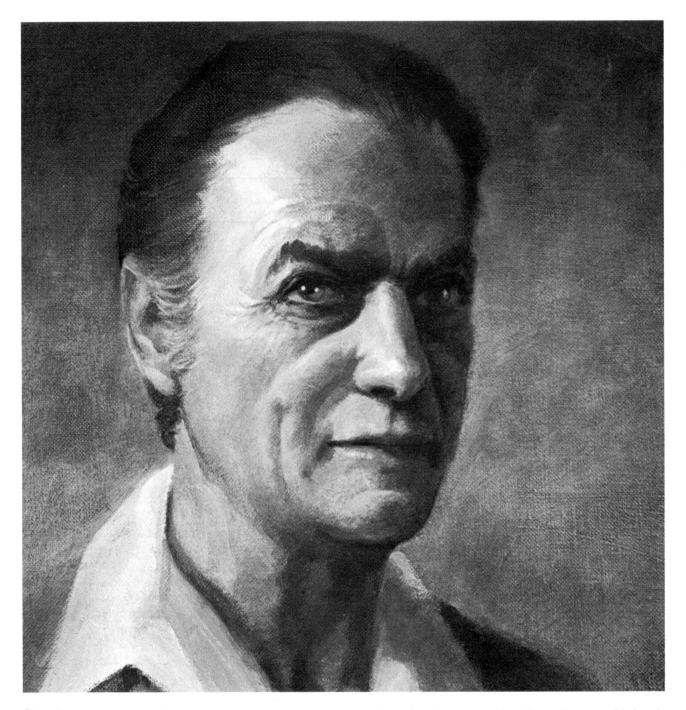

Step 9. In the final stage, a flat, softhair brush picks up just a bit of white and yellow ochre—diluted with gloss medium—and lightly scumbles over the lighted areas of the face, gradually softening the edges and blending them into the darks. All the lines and contours are softened and made more luminous. Compare Step 9 with Step 8, looking carefully at the lighter sides of the brow, cheek, nose, chin, and neck. This scumbled white is quite thin and transparent, softening the darks, but never concealing them. The scumbled strokes are built up very gradually—stopping before there's any danger of covering the darks that were so carefully painted in monochrome. Notice how small

touches of white, tinted with yellow ochre, are added to the wrinkles on the brow and eyes, to the nose, and to the lips. In the same way, an additional glaze of black, burnt sienna, and yellow ochre—diluted with a lot of gloss medium—is scumbled over the shadow side of the face, which becomes darker and contrasts more strongly with the light background. A great deal of gloss medium is added to all these glazes and scumbles to make sure that they're thin and transparent. They must never be allowed to obscure the monochrome foundation on which the entire painting is built. The luminosity of the flesh tones is the result of this transparency.

Improvised Tools. Acrylic is such a versatile medium that artists are still finding new ways of applying paint. Although brushes are certainly the most popular painting tools, artists are always improvising—always coming up with new and unexpected painting tools. Here are some. As you experiment with acrylic, you'll probably come up with others.

Scratching. A dried layer of acrylic paint is a lot tougher than oil or watercolor, but you *can* produce some interesting effects with the sharp point of a knife or the sharp corner of a razor blade. If you're working on illustration board or watercolor paper, you can scratch through a layer of paint to expose the white surface beneath. This can be a very effective way to suggest blades of grass in sunlight or sunstruck twigs against a background of dark trees. If one layer of paint covers another, you might also try scratching away the top layer to reveal a bit of the underlying layer.

Painting with Cloth. You can also roll up a rag into a ball or a rectangular wad, dip this in acrylic color, and apply the paint with a dabbing motion. You actually *pat* the color onto the paper. If the cloth dabber is covered with a lot of color and you press hard, you'll leave behind a fairly solid layer of paint. Less paint and less pressure will leave behind a veil of color. You can also experiment with different textures of cloth: smooth cloth will obviously leave behind a different imprint than rough cloth.

Painting with Paper. Just as you make a dabber out of cloth, you can wad up paper to produce an interesting painting tool. A soft, absorbent paper towel will soak up color and generally leave a soft, blurry mark on your painting surface. A stiffer, less absorbent sheet of paper, such as smooth drawing paper, will make a wrinkled, irregular dabber that will leave a more irregular mark on the painting surface.

Spattering. For subjects like a pebbly shore or a roughly textured stone wall, you can spatter color onto the painting surface. One way is to dip the brush into color, hold one hand stiffly in front of the painting surface, and then whack the handle of the brush against that hand so the color flies off the bristles and leaves an irregular pattern of droplets on the painting. Another way is to dip a stiff toothbrush into liquid color and spray the paint by pulling a flat piece of wood across the bristles.

Sponging. The soft, irregular texture of a natural sponge can become one of the most versatile painting tools. Wet the sponge first, of course, and squeeze out as much water as you wish—depending upon how fluid you want the paint to be. Then dip the sponge into the color on your palette and apply the paint by patting or scrubbing.

Textural Painting. For painting richly textured subjects like rocks or weathered wood, you can use or *create* thickly textured paint. You can work with paint directly from the tube, without water. You can blend the paint with gel medium or acrylic modeling paste or a combination of both. And you can apply this color either with stiff bristle brushes (leaving the imprint of the bristles in the paint) or with any of the improvised tools listed above—each of which will leave its own special texture in the thick color. When that heavily textured layer of paint is dry, you can accentuate the texture with drybrush strokes. Or you can apply very liquid color that sinks into the pits and valleys of the irregular paint surface.

Correcting by Darkening. When things have gone wrong, an acrylic painting is easy to correct. Let's say you've painted a picture in which the drawing, composition, and detail all seem right, but some portion is just too pale. You want to darken that area without covering up all the hard work you've done. A thin wash of transparent acrylic color—diluted with water or with one of your liquid mediums—can be brushed carefully over the offending section. The section will become darker, but the underlying brushwork will still show through.

Correcting by Lightening. What if you have exactly the opposite problem? The drawing, composition, and detail all seem right, but some part of the painting is just too dark. By blending color, water or liquid medium, and just a hint of white, you can create a semi-transparent "fog" of color to wash over the problem area. This veil of liquid color will lighten the offending passage but still allow a certain amount of your careful work to show through. It's usually best to apply two or three very thin veils of semi-transparent color—rather than one heavy coat—to be sure you're not covering up too much.

Correcting by Repainting. Because a dried layer of acrylic paint is insoluble in water, nothing is easier than *repainting* a passage that's gone wrong. You can apply a fresh coat of acrylic gesso to bring that part of the painting back to pure white so you can start again. Or you can just ignore the offending passage and paint over it with fresh color until you get the effect you want—and the problem literally disappears.

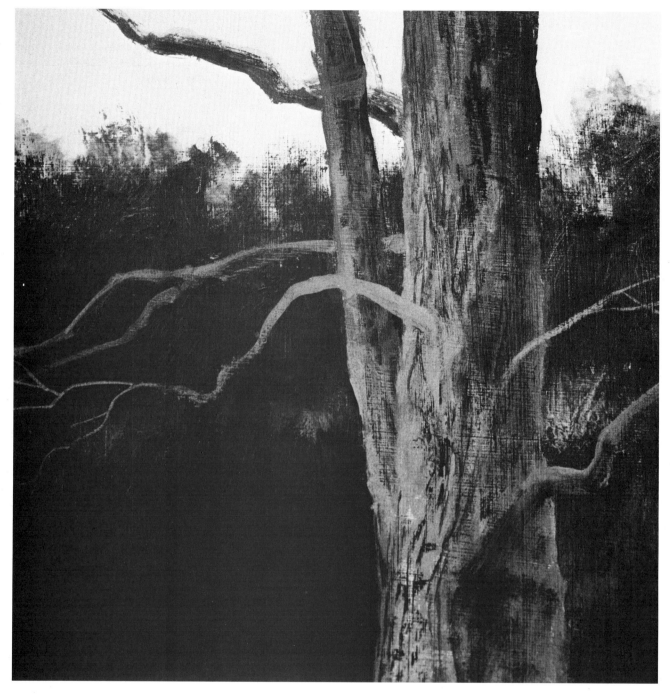

Step 1. This tree and its dark background are painted on illustration board coated with acrylic gesso. The gesso is applied thickly so that the bristles of the nylon house-painter's brush leave grooves in the surface. You can see the texture of these brushmarks peeking through the shadow side of the trunk. At this stage, the picture is painted with broad, rough strokes. You can see a lot of drybrush work in the bark. A few branches and some cracks are added to the trunk with the tip of a round brush. But most of the details will be added in the next stage—with a sharp blade.

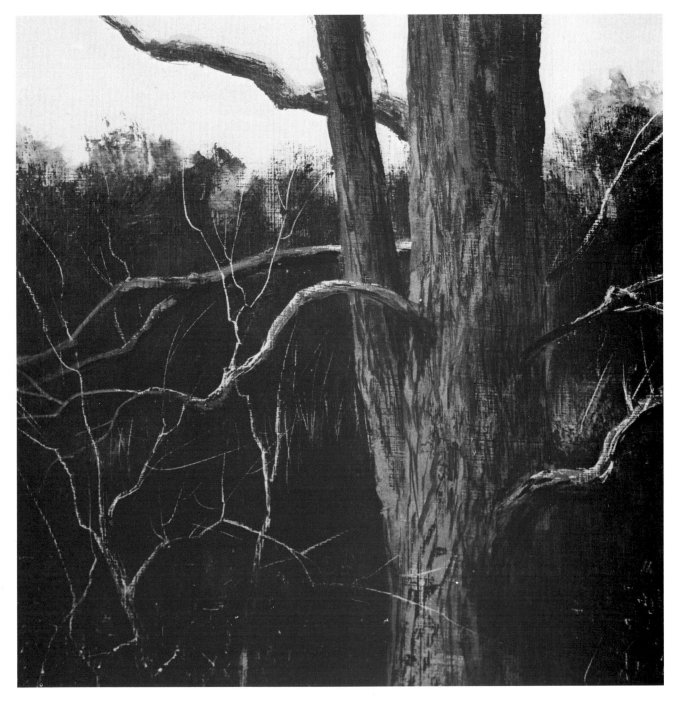

Step 2. When the first layer of paint is completely dry, the tip of a sharp blade—or the corner of a razor blade—scratches into the dark color to reveal the white gesso underneath. The blade lightens the edges of the heavier branches to suggest sunlight striking these branches from above. And a network of smaller branches is suggested to the left of the trunk. The rough texture of the gesso makes the scratches look rough: they're not continuous, wiry lines, but have an irregular texture, like wood. Now the tip of a small, round brush is used to add the final details to the trunk.

Step 1. Brushes and knives aren't the only painting tools. The soft cloud forms in this sky are painted with a rag that's been rolled into a ball, dipped into some paint, and patted against the painting surface. In this first step, the dabber carries a pale tone and is pressed lightly against the illustration board.

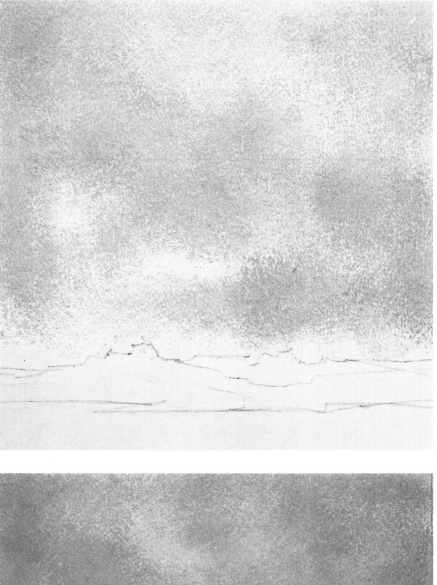

Step 2. Now the dabber picks up a slightly darker tone and presses harder against the painting surface to deposit denser color. The sky is darkened in certain areas, while other areas remain pale to suggest light breaking through the shadowy clouds. Brushes are used to indicate the landscape at the bottom of the picture.

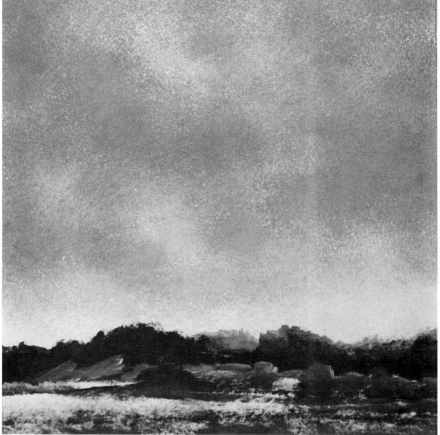

Step 1. Another improvised painting tool is a sheet of paper squeezed into a ball, dipped in color, and pressed against the painting surface. Crumpled paper is particularly effective for painting trees. But it's best to begin by painting the background—like these fields, hill, and sky—and letting it dry before you paint the trees over it.

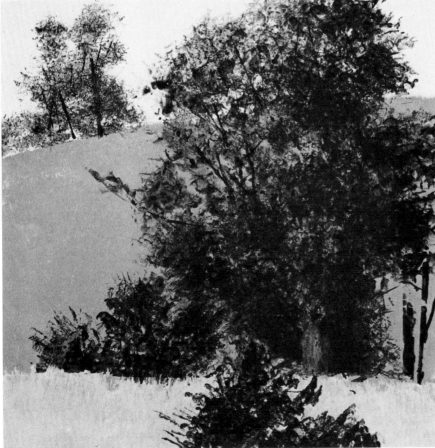

Step 2. A thin sheet of drawing paper is crumpled into an irregular ball, soaked in water to soften the paper a bit, dipped in thick color, and pressed against the painting surface to suggest the clusters of leaves. In the shadow areas of the trees, the paper carries more color and is pressed down harder. Less pressure is applied on the fainter trees at the horizon. When the leaves are dry, a small, round brush adds trunks and branches.

Step 1. One of the hardest subjects to paint is a pebbly beach. You can't possibly paint every pebble. One good solution is to paint the broad tones of the beach with a brush, then follow with the technique called spattering. In this first step, the brush renders the cloud forms in the sky, the shape of the distant dunes to the right and a strip of sea to the left, the overall tone of the beach, and the shadows in the foreground.

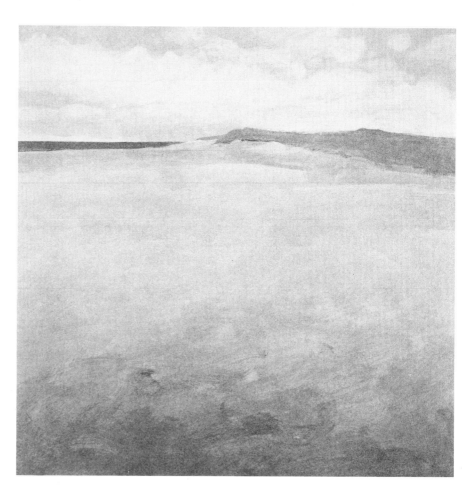

Step 2. Now a stiff brush—it might be a toothbrush, a bristle brush, or a stiff housepainter's brush—is dipped into liquid color. The handle of another brush (or a flat piece of wood such as an ice cream stick) is drawn over the tips of the bristles, which spring back and spray droplets of color against the painting. The brush is dipped first into light color, then into dark color, and then into light color again to produce this pepper-and-salt effect. It's a good idea to cover the distant dunes and sky with stiff paper or masking tape.

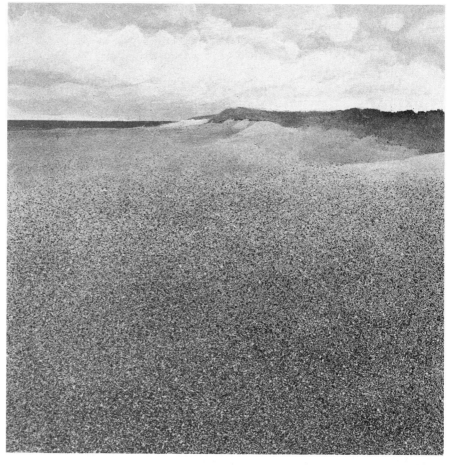

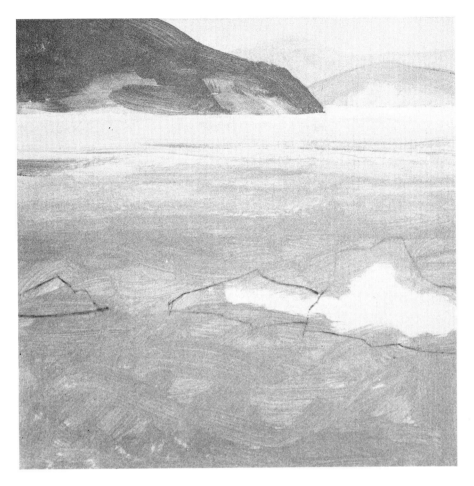

Step 1. If you want to paint a beach with even bigger pebbles, a sponge may be the ideal painting tool. Once again, it's best to begin by painting the major forms of the landscape with brushstrokes. The distant shore, the water, and the beach in the foreground are painted with free strokes. Only the rocks on the nearby beach are left untouched.

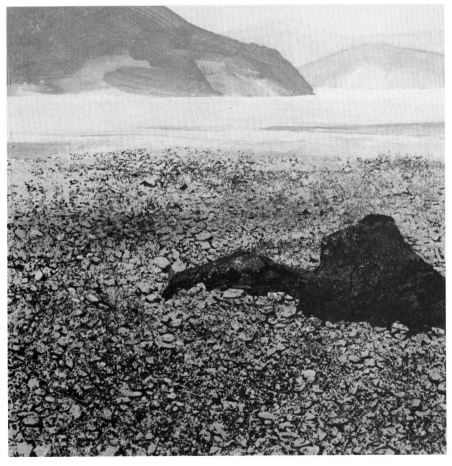

Step 2. A rounded, rough, natural sponge is dipped in clear water, squeezed out until it's just damp, and pressed against a pool of very thick color on the palette. Then the sponge is pressed against the foreground, depositing a pattern of irregular flecks of color. When these flecks are dry, the point of a small, round brush adds a few lines and shadows around some of the bigger flecks to make them look like pebbles. The entire beach is covered with this rough texture, and then the rock is painted right over it with semi-transparent color that allows the marks of the sponge to shine through.

Step 1. A good way to suggest the rough texture of a rock formation is to work with thick, rough paint. This piece of illustration board is first covered with a pale tone that will later become sea and sky. When this tone is dry, the rock formation in the foreground and the smaller rock formation in the distance are both covered with a claylike mixture of acrylic modeling paste, white tube color, and just enough gloss medium to make the paste easier to brush on. The paste is applied with thick, rough brushstrokes and knife strokes.

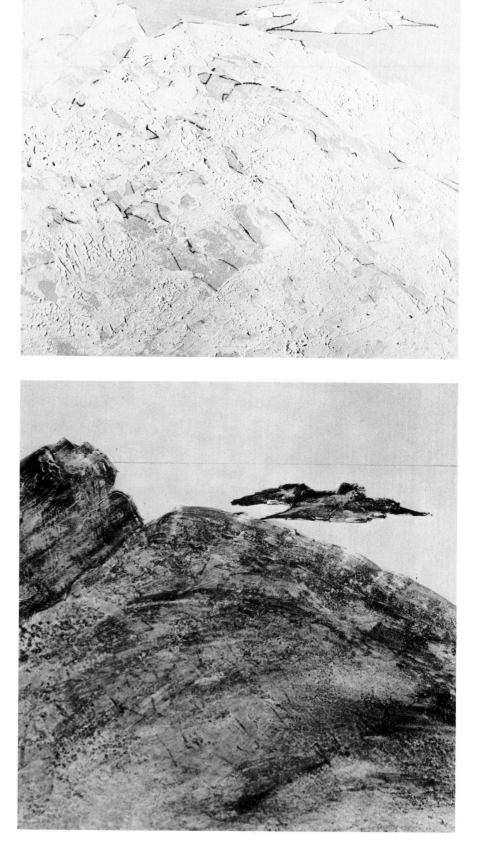

Step 2. When the rocks are absolutely dry, they're covered with liquid color—containing lots of water—which darkens the surface and sinks into the cracks and crevices left by the brush and knife. The dark wash accentuates the rough texture of the thick underpainting.

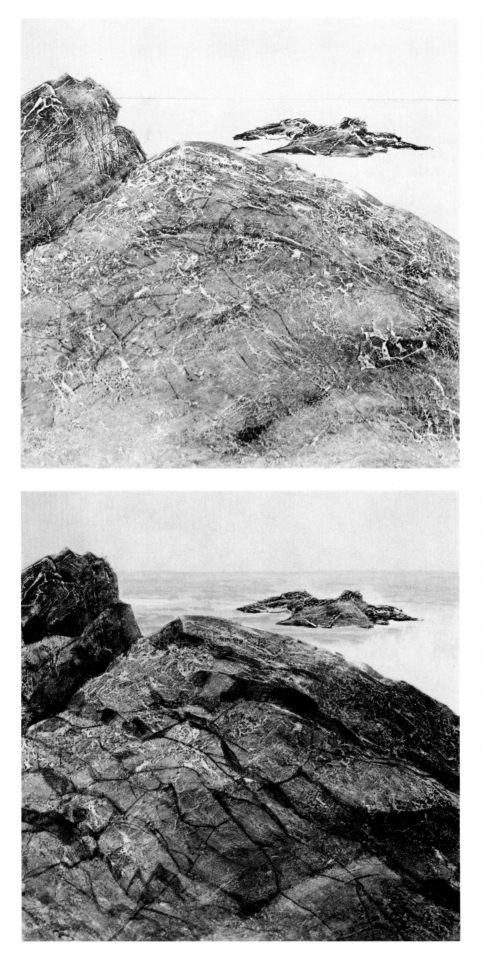

Step 3. When the dark wash is dry, the edge of a sharp blade—not the tip—is skimmed over the rock formation. Wherever the brush and knife strokes stand up highest, the blade shaves them away like sandpaper. (In fact, you might like to try sandpaper.) Now, a network of rough, white lines interweaves with the network of dark cracks and crevices created in Step 2.

Step 4. In this final stage, a round, softhair brush is used to paint shadows, cracks, and other details that complete the rock formation. The tone of the sky is darkened, and the distant sea is painted with horizontal strokes. When you experiment with textural painting, you might also try working simply with thick paint straight from the tube; with tube color and gel medium; and with various combinations of modeling paste, gel medium, gloss or matte medium, and tube color. Some combinations will be thicker and rougher, while others will be smoother and more fluid.

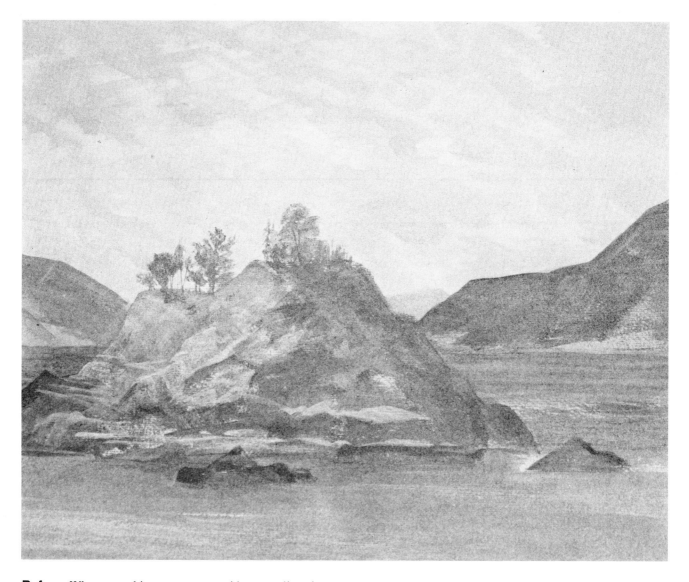

Before. When something goes wrong with an acrylic painting, corrections are easy because acrylic paint is so versatile. One common problem is a painting that's too pale. Everything else seems right: you're satisfied with the composition, the drawing, and the complex pattern of lights and shadows that you worked so hard to render accurately. You know that some parts of the painting need to be repainted—made darker—but you don't want to obliterate the work you've done so far. In this coastal scene, the sky and the shapes along the horizon are just right, but the island in the foreground is too pale; it needs to be repainted so that it's darker and moves forward in the picture. How do you do it?

After. The trick is to repaint the island and its surrounding rocks with transparent color. You mix up a fresh batch of color with lots of water or with one of your mediums—gloss or matte, whichever you prefer. As you brush the liquid color over the painting, you can see right through the strokes and follow all the forms you've labored so hard to render. When the transparent color dries, the underlying brushwork will still show through. If you look closely at the island, you'll see that all the original shadows have been darkened and so have the trees, but none of the original detail has been lost. On the contrary, the detail has been strengthened by dark strokes built on top of the lighter strokes. All the original shapes are still there, but now the island moves forward in the picture, while the distant shapes are much farther away. Because the island and the rocks are now darker, it's important to darken their reflections in the sea below. So the sea is also repainted with transparent strokes.

Before. An equally common problem is some section of a painting that looks too dark. Once again, you've worked hard to get all the details exactly right. The pattern of lights and shadows seems right too. You want to lighten the whole section without covering up your original work and having to redo everything. In this mountainous landscape, there's something wrong with the distant peaks to the left. Because they're too dark, they seem too close—they're not distant enough. The extraordinary versatility of acrylic paint provides the solution.

After. The trick is to mix up a fresh batch of paint that's not transparent, but just *semi-transparent*. You mix the color that you want, add plenty of water or medium, and then add just enough white to make the wash hazy. When you brush this semi-transparent color over the distant mountains, this smoky wash seems to cover the painting surface with a kind of fog through which you can see all your original brushwork. The original pattern of lights, shadows, and details is intact, but everything is paler. The mountains suddenly recede into the distance, where they belong. Beware of one danger, however. It's easy to add too much white to the semi-transparent wash and discover, when the wash is dry, that you've covered up too much. It's best to work in several stages. Add lots of water and just a little white. Brush on one veil of color and let it dry. Then brush on a second veil if you think you need it. And don't be surprised if you need a third or a fourth veil to complete the job.

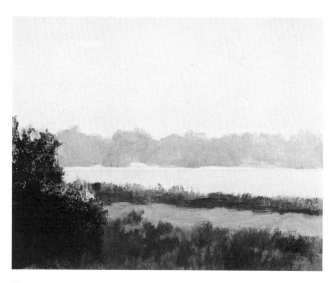

Step 1. How do you correct an acrylic painting if something is in the wrong place—like this tree—and needs to be moved elsewhere in the picture? You've already seen that you can darken an acrylic painting with transparent color and lighten it with semi-transparent color. Here's where opaque color comes into play. The tree is too close to the edge of the picture and needs to be moved toward the center.

Step 2. Working with opaque color, diluted to the consistency of cream and containing a fair amount of white, you can just paint out the tree. Here, the tones of sky, distant shore, and water are just carried over the tree—which disappears altogether.

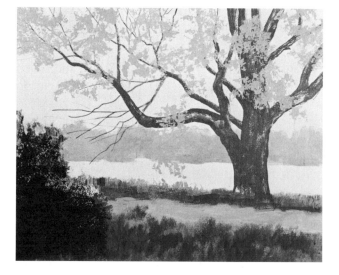

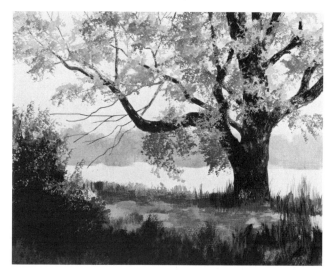

Step 3. When the sky, shore, and water tones are dry, you can just start again. A new tree is painted right over them, starting with the lighter tones of the trunk, branches, and leaves.

Step 4. When these lighter tones are dry, the trunk, branches, and leaves are completed with darker tones and touches of detail. (The leaves are painted with a sponge, by the way.) A shadow is added to the ground at the foot of the tree. Blades of grass are added with the tip of a round brush. The original tree has disappeared totally, and the new tree is in exactly the right place.

Learning the Rules. Acrylic is extraordinarily durable, but this can be a problem if you don't learn certain "rules." The basic thing to remember is that acrylic, once it dries, is almost impossible to remove from any absorbent surface. So be sure to wear old clothes when you paint. Like every artist, you'll get paint on your clothes, and you won't want to bother washing out every spot before it dries. So simply expect to ruin what you wear—and wear something you were ready to throw out anyhow. This includes footwear: wear your most battered old shoes, sandals, or sneakers so you won't worry when they're spattered with paint. You can also expect drops of paint to land on the top of your work table, the floor, and perhaps even the wall. So try to avoid working in a room where you've got to worry about antique furniture, your best rug, or new wallpaper. It's best to work in a room where you can really make a mess. If that's not possible, protect your surroundings with newspapers or the kind of "dropcloth" used by housepainters.

Care of Brushes. Your brushes are your most valuable equipment. While you're painting, always keep your brushes wet, wash them frequently, and (above all) never let acrylic paint dry on the brush. When you're finished, rinse each brush thoroughly in clear water—not in the muddy water that remains in the jars. That rinsing should remove most of the visible color, but there's often some invisible paint, particularly at the neck of the brush, where the hairs enter the metal tube called the ferrule. So it's wise to stroke the brush gently across a bar of mild soap (not corrosive laundry soap) and lather the brush in the palm of your hand with a soft, circular motion until the last trace of color comes out in the lather. Rinse again. When all your brushes have been washed absolutely clean, shake out the water and shape each brush with your fingers. Press the round brushes into a bullet shape with a pointed tip. Press the flat brushes into a neat square with the hairs tapering in slightly toward the forward edge. Don't touch them again until they're dry.

Storing Brushes. Allow the brushes to dry by placing them in a clean, empty jar, hair end up. When they're dry, you can store them in this jar, unless you're worried about moths or other pests who like to eat natural fibers. If these insects are a problem, store bristles, sables, and oxhairs in a drawer or box. Just make sure that the hairs don't press up against anything which might bend them out of shape. Sprinkle mothballs or moth-killing crystals among the brushes. You don't have to worry about synthetic fibers like nylon, which you can leave in the jar if you prefer.

Cleanup. As you work, you'll certainly leave droplets and little pools of liquid color on your work table, your drawing board or drawing table, your easel, and your paintbox. Ideally, you should sponge these up as they happen, but it *is* hard to do this in the excitement of painting. So sponge up what you can—while it's still wet—but then be prepared for more cleanup work after the painting session is over. At that point, the droplets and spills will be dry. If they've fallen on newspaper or a dropcloth, you can just toss out the papers, fold up the dropcloth, and forget about them. But you *will* want to remove dried color from other surfaces. Some of the color will come off if you scrub vigorously with a damp sponge or a wet paper towel: the paint won't really dissolve, but the dampness will soften it, and the friction will rub it away. If that doesn't work, try a mild household cleanser.

Cleaning Your Palette. By the time you've finished painting, a lot of paint will certainly have dried on your palette. You can easily wash off the remaining liquid color, but that leathery film of dried color won't come off under running water. If you're working on an enamel tray or a palette that's made of metal or plastic, the simplest solution is to fill the tray or palette with a shallow pool of cold water and let the dried paint soak for half an hour. The color won't dissolve, but the water will loosen it, so you can peel off the dried color or rub it away with your fingertips. A blunt tool such as a flat wooden stick or a plastic credit card may also help. Don't use a razor blade or a knife, which will scratch the palette. Of course, if you use a tear-off paper palette, just peel away the top sheet and you are done.

Care of Tubes and Bottles. At the end of the painting session, take a damp paper towel and wipe off the "necks" of your tubes and bottles to clean away any traces of paint or medium that will make it hard to remove the caps the next time you paint. Do the same inside the caps themselves. If you do have trouble getting off the cap, soak the tube or bottle in warm water for ten or fifteen minutes. That should soften the dried color in the neck so that you can then wrestle off the cap.

Washing Your Hands. There's no way to avoid getting paint on your hands. So don't eat or smoke while you paint, since certain pigments such as the cadmiums are mildly toxic and should be kept away from your mouth. Wash your hands carefully with soap and water after a painting session. Human skin contains oil, so it won't be too hard to remove dried acrylic color. A small scrub brush will help.

Permanence. The surface of an acrylic painting is far tougher than the surface of an oil or watercolor painting, but *all* paintings require special care to insure their durability. Although the subject of framing, in particular, is beyond the scope of this book, here are some suggestions about the proper way to preserve finished paintings in acrylic.

Permanent Materials. You can't paint a durable picture unless you use the right materials. All the colors recommended in this book are chemically stable, which means that they won't deteriorate with the passage of time and won't produce unstable chemical combinations when they're blended with one another. However, it's not always a good idea to mix one *brand* of acrylic color with another. The good brands are equally permanent, but there are sometimes slight variations in the formulas of the different manufacturers. The biggest problem isn't the acrylic paint; it's the painting surface, which is often less durable than the paint itself. While you're learning, there's nothing wrong with working on illustration board or canvas board, but remember that the cardboard backing will deteriorate with age. Once you feel that your paintings are worth preserving, work on real artists' canvas or prepare your own boards by coating hardboard with acrylic gesso. And if you're working on watercolor paper, invest in "100% rag" stock, which means paper that's chemically pure and won't discolor with age.

Matting. A mat (which the British call a mount) is essential protection for an acrylic painting that's done on watercolor paper or illustration board, since the paper isn't nearly as tough as the paint. The usual mat is a sturdy sheet of white or tinted cardboard, generally about 4″ (100 mm) larger than your painting on all four sides. Into the center of this board, cut a window slightly smaller than the painting. You then "sandwich" the painting between this mat and a second board the same size as the mat. Thus, the edges and back of the picture are protected, and only the face of the picture is exposed. When you pick up the painting, you touch the "sandwich," not the painting itself.

Boards and Tape. Unfortunately, most mat (or mount) boards are far from chemically pure, containing corrosive substances that will eventually migrate from the board to discolor your painting. If you really want your painting to last for posterity, you've got to buy the chemically pure, museum-quality mat board, sometimes called conservation board. Of course, the ordinary mat board does come in lovely colors and textures, while the museum board comes in a very limited color selection. But it's easy to mix acrylic colors to produce the hue that you want for your mat, thin the color to the consistency of cream, and brush it over the museum board. Brush the color on both sides of the board so it won't curl. Avoid pasting your paintings to the mat or the backing board with masking tape or Scotch tape. The adhesive remains sticky forever and will gradually discolor the painting. The best tape is the glue-coated cloth used by librarians for repairing books. Or you can make your own tape out of strips of drawing paper and white water soluble paste.

Framing. If you're planning to hang an acrylic painting that's done on paper or illustration board, the matted picture must be placed under a sheet of clear glass (or plastic) and then framed. Most painters feel that a matted picture looks best in a simple frame: slender strips of wood or metal in muted colors that harmonize with the painting. Avoid bright mat colors or ornate frames that command more attention than the picture. An acrylic painting on canvas, a gesso board, or a canvas board doesn't need a mat or glass. A frame is enough. Since there's no mat, you can choose a heavier, more ornate frame, like those used for oil paintings. If you're planning to make your own mats and frames, buy a good book on picture framing. If you turn the job over to a commercial framer, make certain that he uses museum-quality mat board and tell him *not* to use masking tape or Scotch tape—which too many framers use just to save time and money.

Varnishing Acrylic Paintings. The tough surface of an acrylic painting can be made still tougher with a coat of varnish. The simplest varnish is an extra coat of gloss medium, thinned with some water to a more fluid consistency than the creamy liquid in the bottle. At first, this coat of medium will look cloudy on the painting, but will soon dry clear. If you want a non-glossy finish, follow the coat of gloss medium with a coat of matte medium, again diluted with water to a fluid consistency. If the manufacturer of your colors recommends that you use a varnish that is different from the medium, follow his advice. Apply the medium or varnish with a big nylon housepainter's brush. Work with straight, steady strokes. Don't scrub back and forth too much or you'll produce bubbles. For an acrylic painting framed under glass, varnish is optional. Without glass, a coat or two of varnish will give you a surface that cleans with a damp cloth and resists wear for decades to come.